ONE MILLION
Tattoos

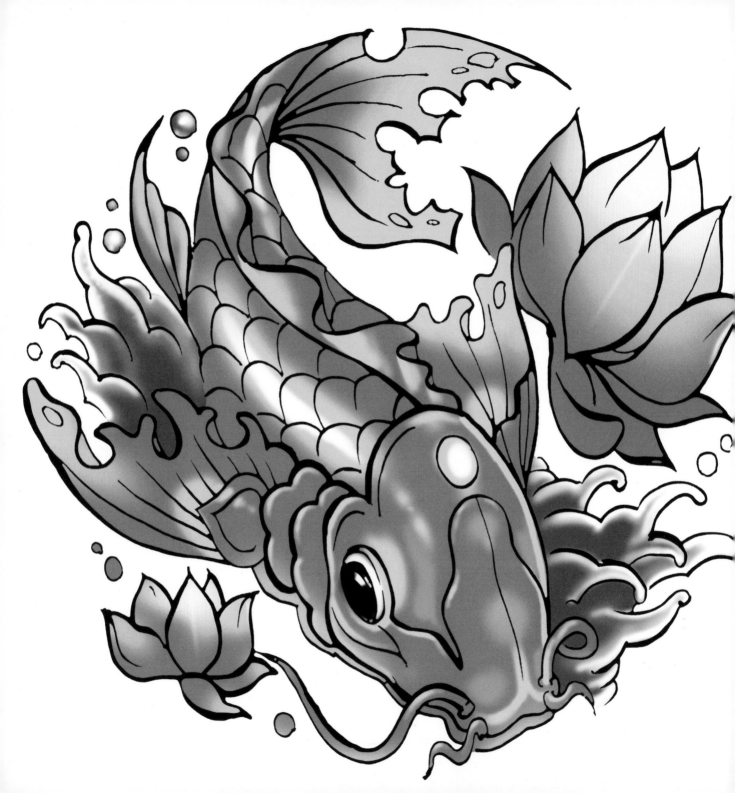

ONE MILLION *Tattoos*

DESIGNS TO CREATE AND COLOR

JIAN YI

with Andrew James

ILEX

ONE MILLION TATTOOS

First published in the United Kingdom in 2010 by:

ILEX

210 High Street

Lewes

East Sussex

BN7 2NS

www.ilex-press.com

Copyright © 2010 The Ilex Press Limited

Publisher: Alastair Campbell
Creative Director: Peter Bridgewater
Managing Editor: Nick Jones
Editor: Ellie Wilson
Commissioning Editor: Tim Pilcher
Art Director: Julie Weir
Designers: Chris & Jane Lanaway

British Library Cataloguing-in-Publication Data
A catalogue record for this book is available
from the British Library.

ISBN 978-1-905814-92-3

Printed and bound in China

Colour Origination by Ivy Press Reprographics

10 9 8 7 6 5 4 3 2 1

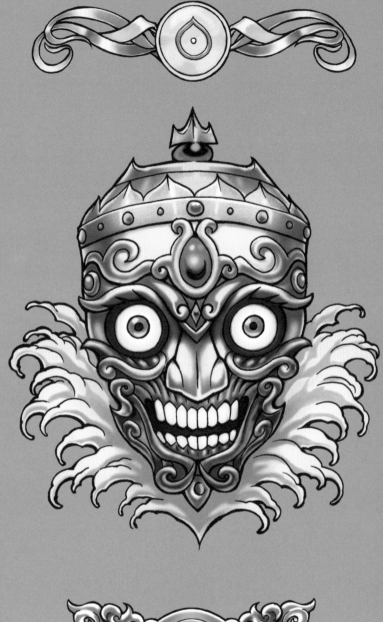

Contents

The History of Tattoo Art

Early tattooing crept in with ritualized scarring—colored dyes or coal dust trapped (accidentally or on purpose) in cuts after the skin healed over. From there, various cultures learned to trap inks under the skin, using needles to apply color for social, religious, and artistic reasons. Tattoos could indicate status, maturity—or even criminality. Facial tattoos could be used by chieftains as a signature of tribal decrees, while other symbols indicated that boys and girls had become men and women, or that their bearer was under the protection of a particular spirit.

While tattooed pagan symbols and woad might have slipped out of favor in the West with the arrival of Christianity, tattooing couldn't be kept down for long. Thanks to sailors who visited Polynesia in the eighteenth century, the practice was revived in the West under the newly acquired word of "tatau." Its popularity has only increased since. While the first sailors adopted the practice for the morbid-if-pragmatic fact that it made their bodies easier to identify if lost at sea, tattooing quickly expanded into more artistic, elaborate areas.

With the increasing legality of tattooing in the latter half of the twentieth century, as well as its prevalence among women as well as men, the art can be truly said to have reached the mainstream. Today, it's estimated that 14 percent of adults in the United States have a tattoo, rising to 32 percent in the 25–29 age group.

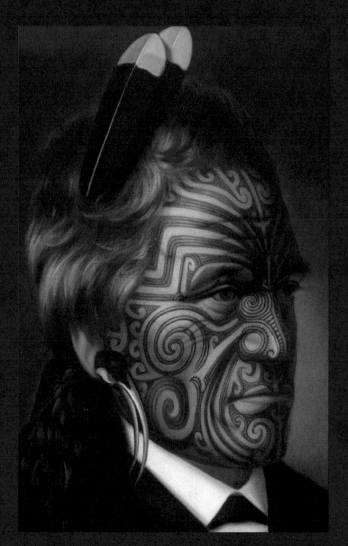

Early Tattooing

A painting of a Maori chief from New Zealand, circa 1880, depicting intricate facial tattoos that symbolize status and affiliation.

6

Tattoo Art Now

As well as becoming more popular, the acceptance of tattooing as an artistic pursuit has only increased since its breakthrough in the 1970s. Tattoo artists can now make names—and extensive client lists—for themselves with their talent and skill, while those in search of inspiration can visit any of dozens of tattoo conventions worldwide to pick up tips, designs, or even work from in-demand artists. Many tattooists now receive extensive gallery exhibitions and television coverage of their art.

The range of modern tattoo designs is unmatched by any period in history. From simple dots to Chinese characters, from initials in the memory of loved ones to elaborate sleeves and back pieces, the variety of tattoos is limited only by the imagination of the artist and the willingness of the client. Simple designs can often be completed in fifteen minutes, while more complex works covering large areas of the body may take multiple sessions of several hours each.

Inks, too, have improved with a wide range of vibrant hues that many tattoo artists blend together into their own unique tones. Some experimental artists offer tattoos that are visible only under UV light, or those designed to break down easily under laser removal treatment.

As well as designs created in tandem by a client and artist, those visiting a tattoo shop will often be able to choose from a wide selection of "flash"— mass-produced designs that can be customized to the client's preference. With the help of this book and CD set, there's no reason not to walk in equipped with the ultimate tattoo design—a perfect image, created, colored, and customized by you!

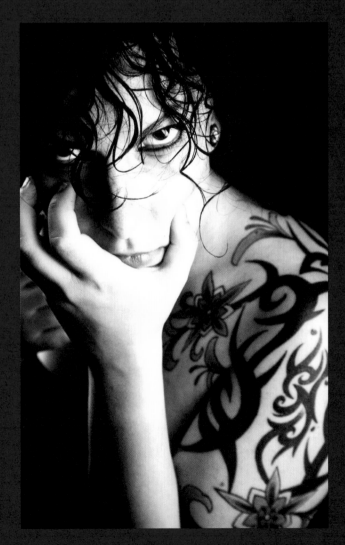

Using the Book and CD

Whatever the scale of your interest in tattoo designs—from skin to clothing or artwork—you'll find everything you need in this book-and-CD collection. This is the ultimate introduction to creating fully realized digital tattoo designs. The first half features stripped-down and easy-to-grasp techniques for customizing designs for your tattoos quickly, simply, and digitally, while the back half of the book contains just a taster of the hundreds of thousands of tattoo possibilities that can be created using this program.

Whether you're an accomplished illustrator with dozens of tattoos or an inexperienced designer looking for inspiration and tips, this book will give you all the foundation you need!

On the Disc
The CD program itself allows you to combine hundreds of pieces of tattoo art in over a million different ways. Choose from over 200 centerpieces, 100 top designs, 100 bottom pieces, and 100 mirrored left and right-hand sides!

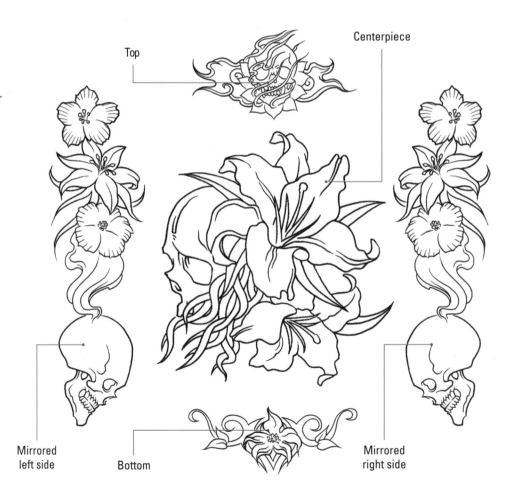

Top

Centerpiece

Mirrored left side

Bottom

Mirrored right side

Taking it Further

There's no need to feel constrained to using the tattoo line art provided on the disc. When you reach the limit of what you can accomplish with the art provided, you'll be ready to incorporate your own creations into new designs. Whether scanned in or drawn digitally, your new art can be seamlessly integrated with the tattoos on the disc. So enjoy yourself, and let your tattoo creativity run wild!

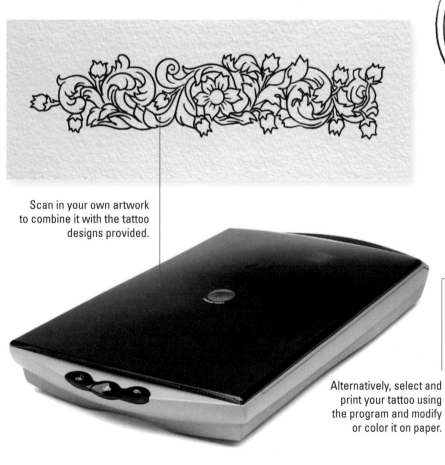

Scan in your own artwork to combine it with the tattoo designs provided.

Alternatively, select and print your tattoo using the program and modify or color it on paper.

Creating Tattoo Designs

There are over a million different combinations of tattoos to create on the disc and the easy-to-use interface makes the process of choosing your one-in-a-million painless. Simply insert the CD and wait for the program to start up or click on the *One Million Tattoo* icon to launch the program. Next, follow the installation instructions.

To create your own tattoo from the disc, simply choose one of the designs from the back of the book and enter the matching codes on the drop-down menus. Alternatively, you can select your own elements from the four drop-down menus on the main interface. Just pick the top, center, lower, and sides you desire. All of the sides are mirror images of one another, to provide balance to the design.

To select different panel designs at random, click on the Lucky Dip button.

Clicking the Copy button will save your design so that it can be pasted onto the clipboard and digitally colored or customized using a photo editing program.

Clicking on the Print button will automatically print a black-and-white image of the tattoo that appears in the preview window. This can then be hand-colored using pens, pencils, or colored inks.

The Quit button allows you to close the program.

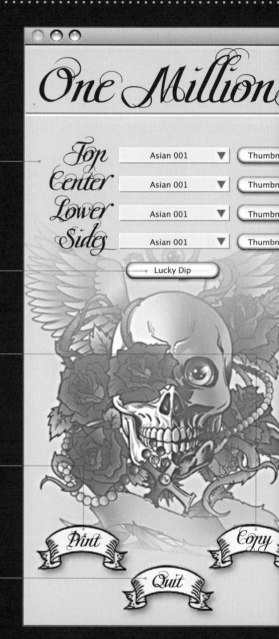

toos

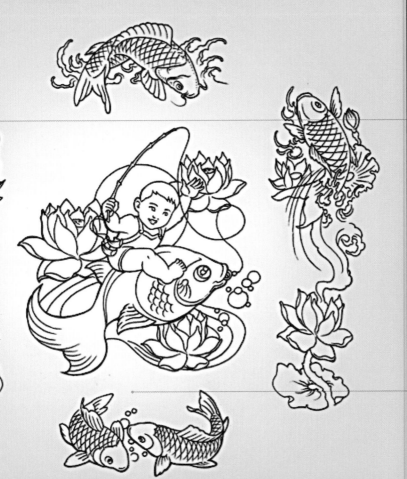

View the different designs for the top, center, lower and side panels by clicking on the Thumbnails icon beside the drop-down menus. Simply click on one of the thumbnail images to preview.

The preview window displays the finished tattoo, based on the selections from the drop-down menus.

Printing

Printing is the easiest part of the process, once the difficult business of deciding on a design is done. One click on the appropriate button is all it takes to automatically print your flash, but there are a number of ways to optimize your output after that.

Getting the Best from Your Printout

If you're going to get something permanent, it's worth investing in a decent printout! If you're printing from home, make sure you have fresh ink cartridges, and that you're happy with the way the design looks on paper compared to the screen. Bright white or glossy paper will display vibrant colors better.

To aid with size and positioning, you may want to print out your work on tracing or transparent paper—or if you're taking something for a test-drive, why not try printing it onto tattoo transfer paper? The paper is relatively inexpensive and you can experiment with hundreds of possibilities from this book—without running out of blank areas of skin!

Many of the designs would also make for incredible T-shirt iconography, so why not try printing them onto T-shirt transfer paper, expanding your wardrobe with something eye-catching and original?

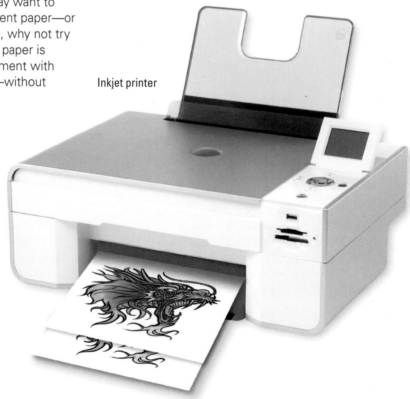

Inkjet printer

Inkjet printers create good-quality color prints, which can be improved further when printing on photographic paper. Alternatively, laser printers are great for printing black-and-white images as the lines are often cleaner and the ink won't smudge from handling or when coloring with markers.

Think Before You Ink

A great tattoo will last a lifetime, but while good tattoos will define your taste and individuality for decades, it's important to remember the permanence of any addition to your skin. Before you commit, you need to be sure that you'll be happy carrying it on your body forever!

Though caution may seem to go against the spirit of tattooing, for all tattoos, small to large, making sure that your design is really what you want is the most important part of the process.

It's worth booking a consultation session with your chosen tattoo artist to discuss any queries you have. This can include everything from the best location for the tattoo, the amount of pain to expect, how long your design will take to apply, the different inks that can be used, and how to take care of the tattoo afterwards.

Getting good aftercare advice is very important. Although each artist's methods may differ slightly, it is crucial to pay attention to their guidelines for aftercare and heed any cautions, so that you are fully aware of the risks involved.

It's good practice to print out your design (in full color) and place it somewhere you'll see regularly everyday—like next to your bathroom mirror. If you still love the design after a month, it's the one for you—but if you're already sick of it, it's good to find out before transferring it to your skin!

Importing Images

The following section deals with customizing your tattoos so you can create truly unique designs. You can do this by saving your design and importing it into an image-editing program, such as Adobe Photoshop, Photoshop Elements, or Corel's PaintShop. You may already have access to this software, but if not, it is easily available. Photoshop Elements is an alternative to the full-fledged program, and works well for customizing your tattoos. The following techniques for designing your own tattoos are all examples from Photoshop Elements.

1 To import your tattoo into Elements, click on the Copy icon to copy your design to the clipboard.

2 Open Photoshop Elements and select File > New.

3 This will open the New Document dialog. Set the Color Mode to RGB, the Background to White, and click OK. You can also choose to set the Resolution of your image, although this is optional. Here it is set to 300 ppi. The higher the resolution, the less pixelated your line art will be.

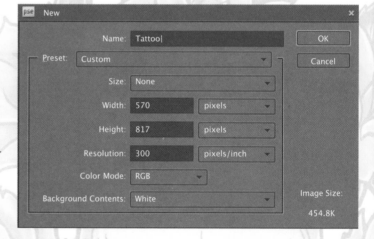

4 Paste your tattoo into the New Document (press Ctrl/ Cmd + V). This places your tattoo onto the clipboard as a "Vector Smart Object." Click on the tick in the Toolbar above your document, or press Return (Enter), to secure your tattoo vector to your page.

5 Next, "flatten" your image to a single layer by selecting Layer > Flatten Image from the menu, or by pressing Ctrl/ Cmd + E. You can start coloring right away—just create a new layer and set it to "Multiply" if you want to quickly lay down some colors over the top of your linework—or you can try out some of Photoshop's settings to refine your line art first (see page 28).

TIP: Copying to Clipboard

There are many applications that allow you to paste your tattoo onto the clipboard. In Windows you can paste your tattoo directly into Paint or even Microsoft Word. You can then save your tattoo and email it to a friend!

14

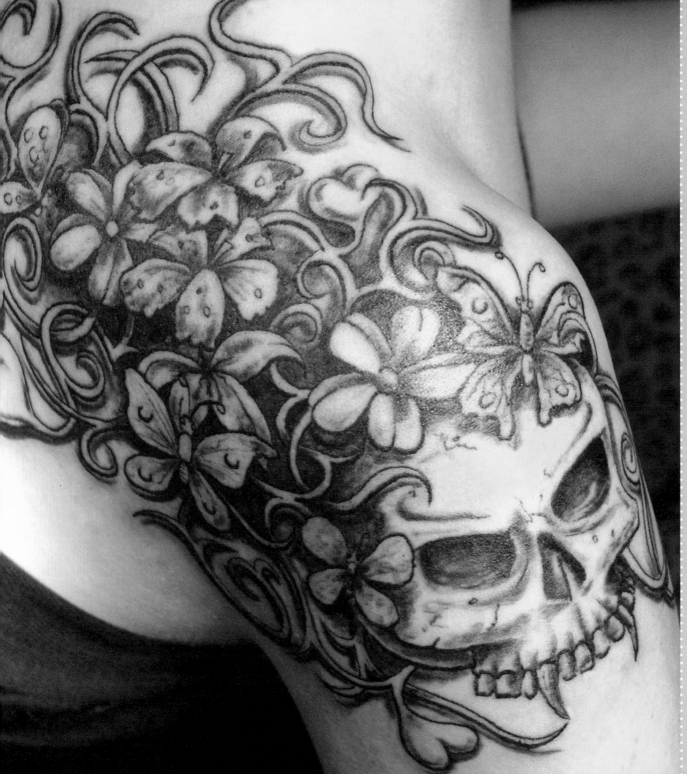

Digital
Tattoo Art

Editing Programs

Editing programs offer a range of cool and useful imaging tools making them perfect for design and coloring. For illustrative purposes, we will use Adobe Photoshop as an example. It comes in two versions: the full-feature image-editor, and Photoshop Elements, a simplified version for home use. But most editing programs are ideal for coloring your tattoo designs.

Toolbox

Although they differ slightly, both versions of Photoshop have a Toolbox, which appears by default on the left of the window. This is where you select different functions.

Tool Options

Here is where you fine-tune the tool you've selected. On the Brush tool, for example, you can select the size and opacity of the tip.

Palettes

These floating windows are palettes. The most useful is the Layers palette, which allows you to switch between different layers of your image—for instance, between your black and white design and the colors above or below it. Switch by clicking the box to the left of the layer: an eye icon means a layer is visible. The current layer is shown with a colored or darker bar.

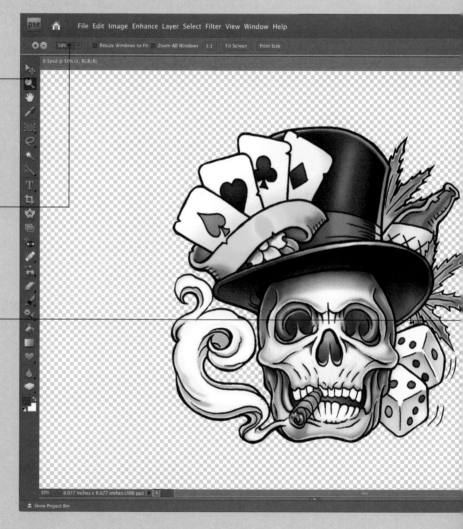

Navigator Window

This window lets you move around a document quickly without using the Toolbox or keyboard, and also lets you keep one eye on how your design looks as a whole, even when zoomed in.

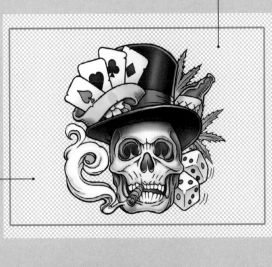

TIP: Pixels

The larger the monitor, the more of your design you'll be able to fit on the screen at once. If you often zoom in and out to work on fine details, don't forget to keep checking your artwork at 100 percent to make sure you're happy with the balance of the image as a whole.

Layers

Layers are the most useful innovation of digital imaging—allowing you to stack different components on top of one another so that you can change each individual element—the colors or the linework for example—without impacting on the rest of the picture. You can even experiment with alternate color schemes in the same image, just by turning layers on and off!

Basic Tools

Check out the main tools in the Photoshop Elements Toolbox. You'll find very similar tools in Photoshop itself—we've covered the essentials available in both versions.

Terminology

Occasionally we'll drop a time-saving keyboard shortcut on you: while the letter is usually the same, control keys vary between Windows computers and Macs, so Ctrl/Cmd + Alt + C means to hold the keys marked Ctrl and Alt and tap C in Windows, but to use the keys marked Cmd + Alt + C on a Mac.

Navigation Tools

 Move

Click and drag to move the currently active layer or selection.

 Hand

The Hand tool lets you scroll around the image without moving the design itself, which is useful if you're zoomed in. Press the space bar to activate it while coloring.

 Zoom

Zooming enlarges or reduces the preview of your image. Holding Ctrl/Cmd and pressing the + and − keys allows you to zoom in and out at any time. Pressing Alt and using the scroll wheel on your mouse has the same effect.

 Eyedropper

The Eyedropper tool changes the foreground color to one you click on (current colors are at the bottom of the Toolbox). The Alt key temporarily changes the Brush tool into an Eyedropper. Don't forget that pressing X swaps your foreground and background colors, so you can pick up one color, flip, and pick up another.

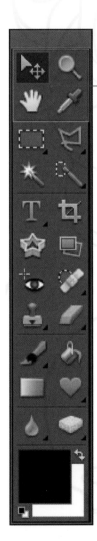

Navigation Tools

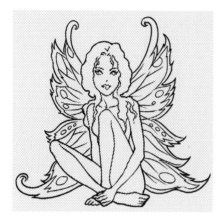

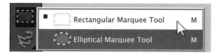

Paint Tools

Selection Areas

Selections are used to control which parts of your design are affected by your painting or coloring. A selection outlined by "marching ants" can be colored without affecting the areas around it—you can use it to quickly flood-fill areas rather than coloring large areas with the Brush tool.

Selection Tools

Accurate selections mean quicker, more accurate coloring. Choose the tool that's right for you.

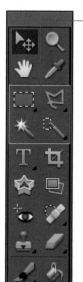

Selection Tools

TIP

Hold the Shift key when using a selection tool to add a new selection to an existing one. Hold Alt to delete from an existing selection. The + and – signs next to the mouse cursor indicate whether you'll be adding or subtracting.

Marquee Tools

The simplest selection tools are the Rectangular and Elliptical marquees. Highlight a rectangle or ellipse on your document by clicking and dragging. Holding Shift while you drag gives a perfect square or circle.

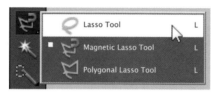

Lasso Tools

These tools allow you precise control. The Freehand Lasso requires a constant, steady hand. The Polygonal Lasso creates a similar selection, but draws lines between waypoints you define, meaning you can lift your finger between clicks.

 Selection Brush

The Selection Brush, a Photoshop Elements exclusive, allows you to "draw" a selection directly onto your picture. Photoshop has the Quick Mask feature instead, where you can use the standard Brush to "paint" the mask on a new layer.

 Magic Wand

The Magic Wand tool allows you to select areas of a specific color in the image: great for selecting areas in your tattoo, and also for reselecting areas of flat colors once you have applied them.

Paint Tools

The paint tools are used to draw lines and add color to an image. Check out pages 28–33 for an in-depth guide.

 Pencil

The pencil creates pixel-perfect lines; the same as the Brush tool, only without any blurring or blending. It's great for fixing or altering your tattoo linework, or applying clearly defined areas of flat color.

 Paintbrush

The standard painting, drawing, and coloring tool, useful for soft edges and smooth lines. A wealth of styles are available in the Tool Options bar.

 Eraser

The Eraser works just like a normal eraser. On a flat image, it rubs away to the background color. On a stacked layer, it will erase to show the layer underneath.

 Paint Bucket

This tool fills an area with a selected color or pattern. Click on an area and it will be filled to its edges—the point where an area of color meets another significantly different to its own. You can adjust this level of difference, called Tolerance, in the Tool Options bar.

21

Basic Brushes

The Brush and Pencil tools are the most basic yet versatile ways of adding lines and color. Brush settings control whether a brush is opaque like paint or translucent like a marker pen, and whether it blends or overdraws. The nib can be blunt or pointed, or even made of a custom shape. You will probably only want to use the simplest and boldest settings when coloring your tattoos, but it never hurts to know what Photoshop is capable of!

Brush
Choose the type of brush you want to use from this menu. Pressing < and > moves through the range.

Size
Make your chosen brush smaller or larger, or use the [and] (square bracket) keys for the same purpose.

Opacity
How transparent the ink or paint will be; 0% is invisible, 50% is half-transparent or semi-opaque, and 100% is completely solid. You can choose any number in between.

 ### Airbrush
This changes the brush to Airbrush mode, which gives you a gradual flow of paint (depending on the Flow setting). Although this is a useful effect, it is hard to replicate using a tattoo machine, so it is best used sparingly!

Brushes:	Default Brushes				
1	3	5	9	13	19
5	9	13	17	21	27
35	45	65	100	200	300
9	13	19	17	45	65

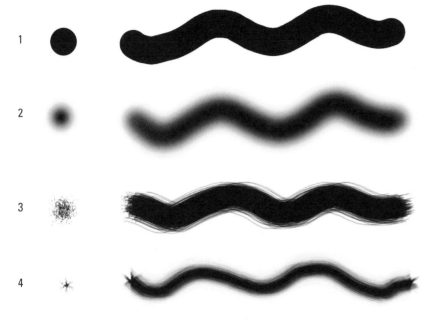

1

2

3

4

Brush Shapes

 Hard brush (1)

These brushes give you a solid shape and smooth outline. The edge is softened, but still gives a sharp division between two colors.

 Soft round (2)

These brushes have a gradient of density, their opacity reducing toward the edge of the basic shape, making them perfect for gently blending colors together.

 Natural brushes (3 + 4)

You can emulate "natural media" like paints, pastels, and charcoal with irregularly styled brushes. The brush menu contains a wealth of exotic patterns and shapes that may provide you with inspiration.

KEYBOARD SHORTCUTS

Quick Brush Resizing

The [and] keys quickly resize your brush (holding down the Shift key at the same time lets you alter the hardness). This lets you rapidly adjust your level of detail without having to zoom out or shift your focus from a tricky part of the tattoo.

Quick Color Changes

When working with the Brush or Pencil tools, you'll often want to change color quickly. By holding the Alt key and clicking over a pixel of the color you want, you pick up that color from the canvas. (You might even want to keep some dabs of color on your image to choose from until you're done). Another good friend is the X key, which quickly alternates between the foreground and background color.

Painting with Opacity Controls

The number keys along the top of the keyboard act as handy shortcuts for adjusting the opacity of your brush. Press 1 for 10% opacity, 2 for 20% opacity, etc. If you press 2 and 5 quickly, you'll get an opacity of 25%. This is useful if you want to introduce some blending or subtlety to your coloring, but don't want to change color. These shortcuts, combined with using the X button, can allow for very fast monochrome coloring!

Basic Techniques

Resizing, rotating, and flipping. You can use the Free Transform tool (Edit > Free Transform, or keyboard shortcut Ctrl/Cmd + T) to personalize your chosen tattoo designs even further. Select an area of the line art using any of the selection tools (the Marquees are most useful), then rotate, resize, or mirror that element using the Free Transform tools, or the Transform Controls indicated by white control points around the border of your selection.

If the Transform Controls aren't visible, turn them on by creating a selection, switching to the Move tool (press V), then check the box marked Show Transform Controls in the Tool Options bar.

The only disadvantage of Transforming a black-and-white image is that you'll anti-alias (soften and blur) parts of your picture: this can make "flood fills" when coloring with the Paint Bucket less effective. You can remove anti-aliasing by adjusting the "Threshold" of your line art (see Step 2 on page 28).

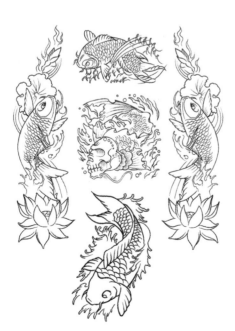

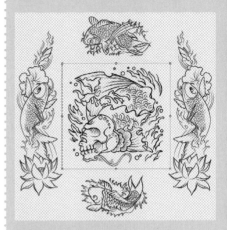

1 Select the portion of your image you want to rotate or change in size (scale) by drawing a selection around it, switching to the Move tool, and choosing Free Transform or Transform > Scale—or use the Transform control points that appear around the selection.

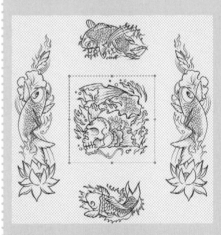

2 Use the white control points at the corners of the selection to drag it larger or smaller (holding down Shift as you do so will keep the selection in proportion), or enter a percentage in the Tool Options bar.

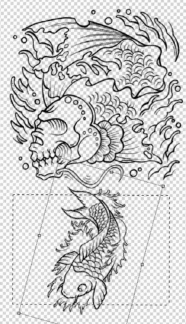

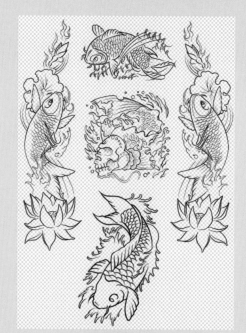

4 When you've finished adjusting your image, press the Enter key (or the tick icon on the right side of the Tool Options bar). If you're not happy with it, press the Escape key (or click the red cancel icon) and your selection will jump back to its original state.

3 To rotate a selection, you can choose Edit > Transform > Rotate, or, with Show Transform Controls enabled, hover the mouse just outside one of the corners of the bounding box until the cursor turns into a curved, two-ended arrow. Dragging to the left or right rotates the whole selection—you can also enter precise degrees in the Tool Options bar.

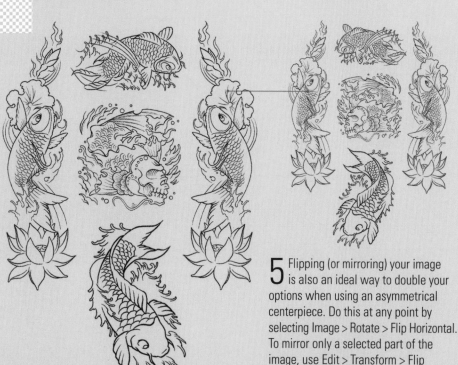

5 Flipping (or mirroring) your image is also an ideal way to double your options when using an asymmetrical centerpiece. Do this at any point by selecting Image > Rotate > Flip Horizontal. To mirror only a selected part of the image, use Edit > Transform > Flip Horizontal/Flip Vertical.

Customizing Tattoos

You don't have to stick to the five-part template that the designs on the program follow. Using the techniques covered on pages 24–25, you can use the artwork provided with *One Million Tattoos* to customize your tattoo however you like. The composition of your design may depend on where you plan to position it; for example, the five-part design is ideal for placing on a shoulder or the lower back, while a single side panel would look great on a forearm.

A simple way to tweak your composition is to use the Blank option in the drop-down menus. You can choose which parts of template you want to leave out, for example the Side panels. You may want to leave a panel blank and include some of your own artwork instead.

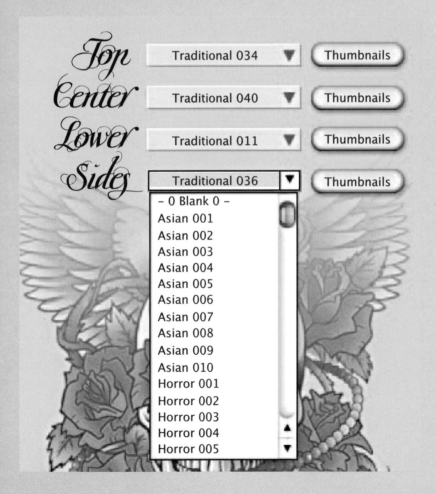

Top — Traditional 034 ▼ — Thumbnails
Center — Traditional 040 ▼ — Thumbnails
Lower — Traditional 011 ▼ — Thumbnails
Sides — Traditional 036 ▼ — Thumbnails

– 0 Blank 0 –
Asian 001
Asian 002
Asian 003
Asian 004
Asian 005
Asian 006
Asian 007
Asian 008
Asian 009
Asian 010
Horror 001
Horror 002
Horror 003
Horror 004
Horror 005

Alternatively, you may want to get a little more creative. By resizing, rotating, and flipping your panels you can end up with dramatically different designs.

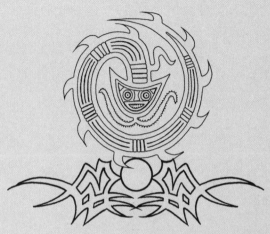

Choose the elements you want to use in your tattoo design and copy them over to your image-editing program (see pages 14–15).

Here, the side and top panels have been deleted, and the lower panel has been resized and moved to sit just under the central motif.

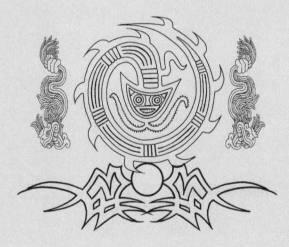

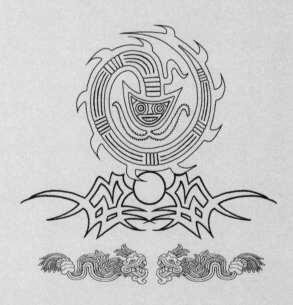

Above, the side panels have been flipped vertically and resized.

The side panels can be used as top and lower panels as well. Here they have been positioned to face each other by deleting the left piece, copying the right side, and flipping this horizontally.

Blocking in Color

Filling in base colors is the first step in every coloring process. Flat colors block out the areas of color that serve as boundaries for the more detailed coloring to follow.

Remember that the more colors you use, and the greater the amount of shading and gradation, the longer the tattoo will take, and the more difficult it will be to apply. Simpler, bolder designs with limited numbers of colors will often work the best—sometimes flat colors will be all you need.

Creating blocks of solid color on a separate layer also allows you to easily reselect large areas of color with the Magic Wand tool—but be sure to keep a copy of your flats layer, even after you start shading, so that you can come back to areas of color later if you aren't happy with them.

Preparing the Artwork for Color

When you have copied your tattoo to the clipboard, you should prepare it to be colored or toned. It's important to flatten an image and make sure that no anti-aliasing is present, as blurred lines can prove tricky during coloring. Nothing is worse than ragged graytones around all of your lines!

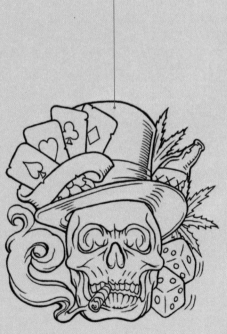

1 Choose Layers > Flatten Image from the menu. This will reduce the image to a single layer.

2 Choose Filter > Adjustments > Threshold. Adjust the slider until you are happy with the "boldness" of your lines. This means that any colors above a certain percentage of "darkness" will become black, and any below will be white.

As well as setting your resolution, another way to optimize your line art is to try out some of Photoshop's Sharpen filters, such as the Smart Sharpen filter. Or in Elements, apply the Sharpen effect and adjust the Threshold.

Laying Down Flats

1 Most of the tattoo designs have solid black lines for easy coloring. If you wish, you can just use the Paint Bucket tool set to Contiguous to fill them. If you want a little more control, duplicate the line art to a new layer. Using the Magic Wand tool, with Contiguous unchecked, click on an area of white, then press Delete. This will select and delete anything that isn't line art. Delete the artwork on the original line art layer, replacing it with a flood fill in a neutral color such as gray or pale yellow.

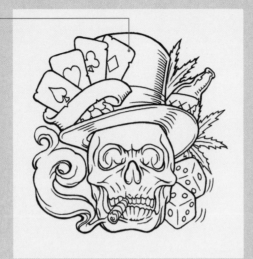

3 Now click Select > Modify > Expand, set the value to 1, and click OK. This expands the area of color out over the linework so that there are no gaps in the color when printed or viewed on screen. When you've finished selecting one group of areas, switch to the color layer below.

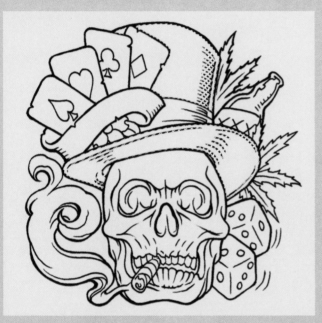

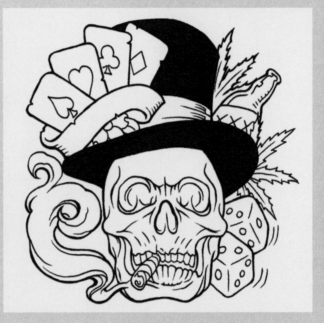

2 On the line art layer, use the Magic Wand tool to select an area you want to block color in. Set the tolerance to about 35, check Contiguous and uncheck Anti-alias. Press and hold the Shift key to select multiple areas (all parts of your tattoo you want in the same color, such as a flower's petals, for instance) or press and hold the Alt key to deselect any areas you may have clicked by accident.

4 Using the Paint Bucket tool, fill the selected area with your chosen color. You can also get the same result by pressing X to switch your chosen color to the background color, and pressing Delete. It's quicker over multiple areas.

5 Sometimes you will want to use the Pencil tool to fill in small problem areas not easily selectable, or areas not fully enclosed by the line art. Use the [and] keys, or the right-click menu, to increase or decrease the brush size.

6 Repeat the above steps to fill in all the colors. Coloring is time-consuming but worth it!

7 Use the Eraser tool to clean up any overlapping areas.

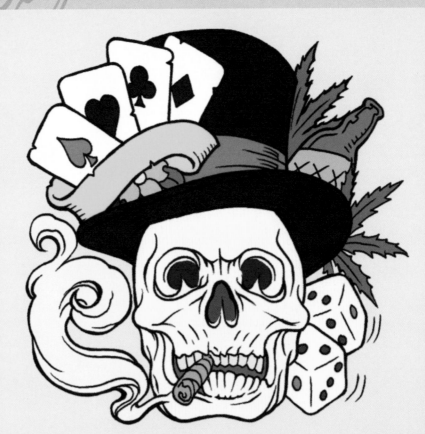

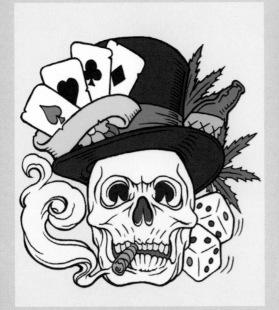

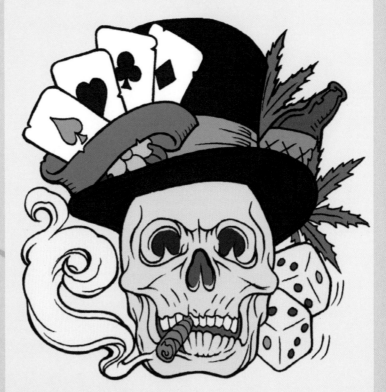

8 If one color you have filled looks out of place next to another, you can adjust it. Use the Magic Wand to select the area of color you want to change (if you've used the color in more than one location on your page, deselect Contiguous and the Wand will select all the places that color appears on the page), then go to Image > Adjustment > Hue/Saturation and push and pull the sliders until you're happy with the new color. You can also use the same command to change the Hue and Saturation of your entire image—just make sure you've deselected any small selections first.

Shading and Highlights

The brushes in Photoshop make creating great airbrush and simulated natural media effects easy! Due to the possibility of using hundreds of colors, these effects are great for designs you're intending to use on a tattoo transfer, T-shirt design, or other decal.

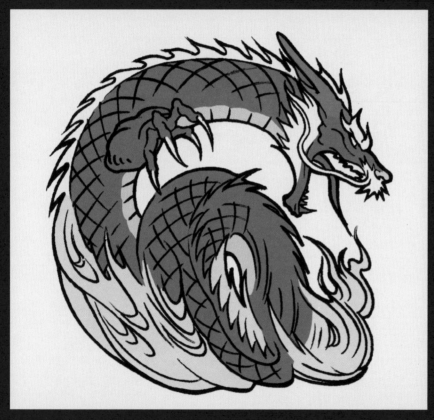

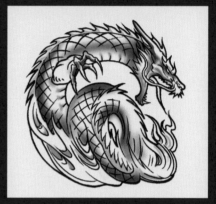

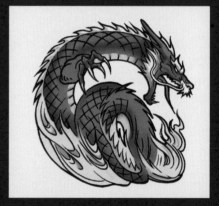

1 After blocking in base colors, duplicate the layer (Layer > Duplicate Layer). Rename the duplicate and leave its mode on Normal, then move it above your base layer. Keep the original base layer, as it will help you select areas of flat color with the Magic Wand. You will be doing all of your painting on the duplicate. Don't use the Eraser to correct mistakes, as it will erase through to the layer below: use a brush to paint over the fault with the original color.

2 Select the color you want to work on, using the Magic Wand with Contiguous unchecked. Choose a color that's a few shades darker (not a shade of gray). With the Paint Brush tool, select a soft tip and set the opacity to around 30%.

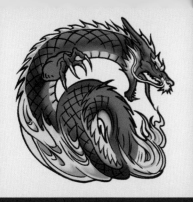

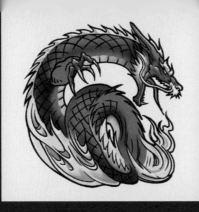

5 Repeat this process for the other parts of the picture. Pay attention to the material you're painting, and how reflective or shiny it might be. Use the Hue/Saturation controls to tweak finished areas until you're satisfied. Here's where keeping your base colors as a separate layer comes in handy: painted colors are tough to select in their entirety with the Magic Wand. Just click back to the base layer, select the area of flat color you want to adjust, then flip back to the color layer to alter the selection as necessary.

3 You can paint directly onto the color within your Magic Wand selection selecting each area of color keeps your shading inside the lines). With an opacity as low as 30%, you can build the darker color up gradually, overpainting your shading with darker shadows. If you think the shadows are not dark enough, simply choose a darker tone.

4 Once the shadows are complete, move on to the highlights—choose a lighter color than the original and paint areas that especially catch the light. Build the highlights up gradually with a soft-tipped, low-opacity brush.

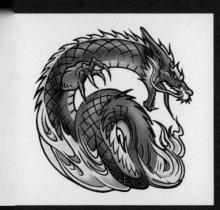

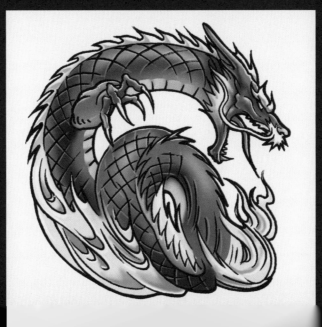

6 Next, add the strong highlights. Create a new layer above the color layer, name it "Highlights," and leave the mode as Normal. Pick a hard-tipped Brush with 30%–100% opacity, then paint in bright white (or very light) shades to finish toning

7 Lastly, add any further details to complete your tattoo

Adding Tattoos to Artwork

You can incorporate your original tattoo designs into any existing art. Once you have saved your colored design as a TIFF or JPEG image you can copy, paste, and insert them into any variety of scenes. Either copy and paste your finished file, or drag the appropriate layers from your tattoo window to the destination image.

1 Import your finished tattoo design into your artwork as a new layer. If your tattoo is especially large, you will want to color it beforehand and flatten the art into a single layer before importing it, as it will be very difficult to color once resized. Once it is complete, use the Magic Wand tool to select the areas of white around the flattened tattoo art, then choose Select > Inverse (Shift + Ctrl/Cmd + I) to get a precise selection of the tattoo.

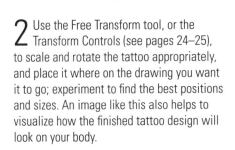

2 Use the Free Transform tool, or the Transform Controls (see pages 24–25), to scale and rotate the tattoo appropriately, and place it where on the drawing you want it to go; experiment to find the best positions and sizes. An image like this also helps to visualize how the finished tattoo design will look on your body.

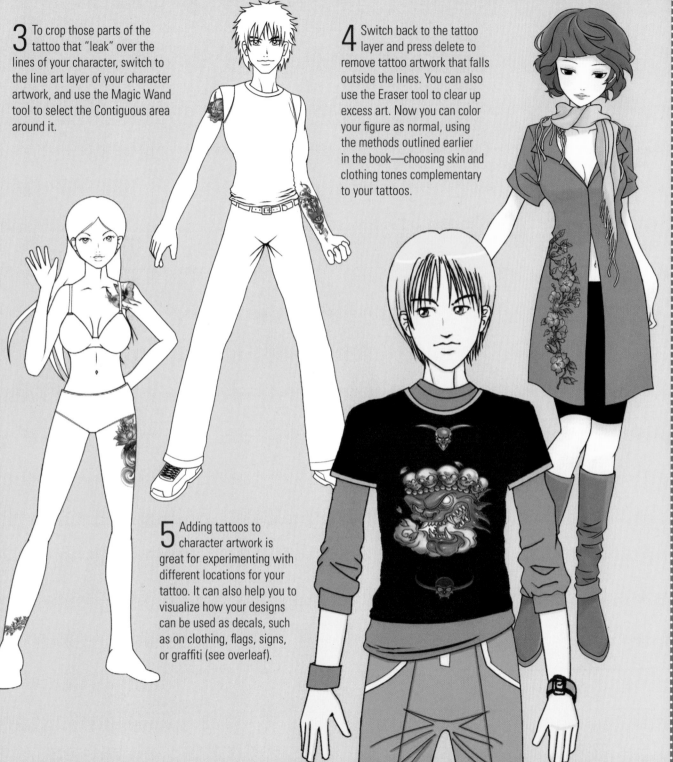

3 To crop those parts of the tattoo that "leak" over the lines of your character, switch to the line art layer of your character artwork, and use the Magic Wand tool to select the Contiguous area around it.

4 Switch back to the tattoo layer and press delete to remove tattoo artwork that falls outside the lines. You can also use the Eraser tool to clear up excess art. Now you can color your figure as normal, using the methods outlined earlier in the book—choosing skin and clothing tones complementary to your tattoos.

5 Adding tattoos to character artwork is great for experimenting with different locations for your tattoo. It can also help you to visualize how your designs can be used as decals, such as on clothing, flags, signs, or graffiti (see overleaf).

Adding Tattoos to Decals

As well as incorporating your designs into character artwork, you can also use the same imagery to create great decals to spread your creativity over school and college textbooks, clothing, bags, vehicles, and more, as stickers, transfers, and reference for paintings.

1 There are a wide variety of specialized printer papers out there, all of which can extend your enjoyment of your designs. Temporary tattoo papers can show you what your design will look like in place, so you can "road-test" the flash more thoroughly. Iron-on T-shirt transfers can give your clothing a new look quickly and easily, and peel-and-stick decals can add individuality to a schoolbag, skateboard, cellphone, or laptop!

2 Virtually all custom T-shirt printers will accept digital files, in either JPEG or TIFF formats, if you want a more professional end result, and the same printers will often offer custom tote bags, caps, and more. Shop around on the internet for the best quote, and double-check your exported files before you send them. Many T-shirt printers will allow you to specify an area of the design as transparent (most often the white background of the image), so bear this in mind.

3 If you're in a band, have a club night or organization to promote, try adopting a design as a logo for flyers, business cards, or invitations. You could also use cheap sticker-paper to create quick, simple, and memorable giveaways for your event—and birth your own grassroots brand!

4 If you want to mix up the digital precision of your design, why not borrow or hire an artist's overhead projector? Project a printout of your image onto a T-shirt, bag, or even an area of wall, and use fabric or regular paints to duplicate the projected image. This also works well if you want to shake up a kickboard design without having to worry about measurements or rough pencils— just turn the projector on, mix up the paint, and go!

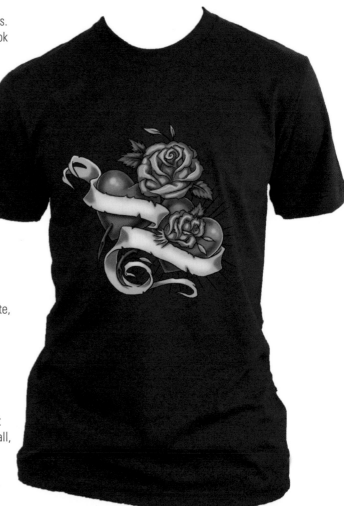

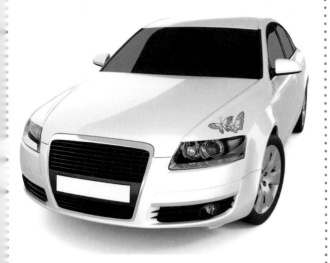

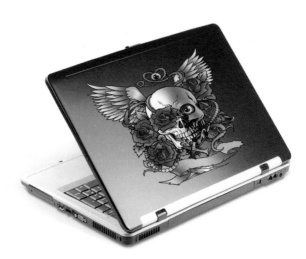

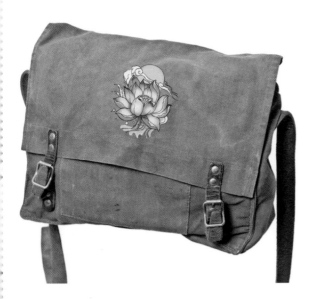

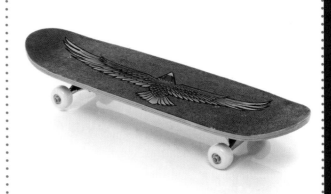

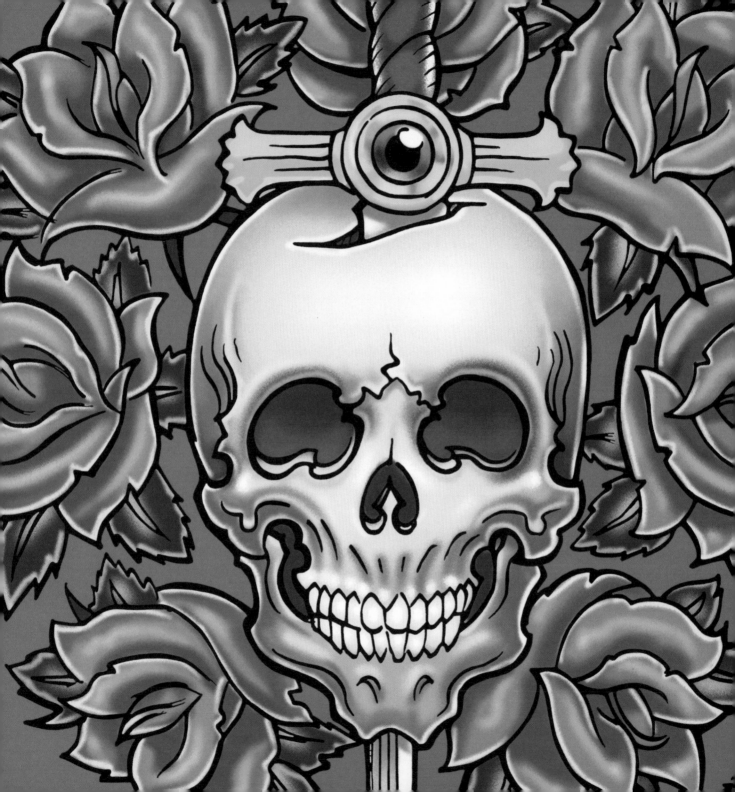

Tattoo Designs

Traditional

Traditional

The traditional tattoos feature motifs of hearts, skulls, daggers, crosses, and roses. Mixing Gothic skulls with delicate flower designs can create effective contrasts, while using elements from the other tattoo styles gives a contemporary feel to classic designs like the love heart.

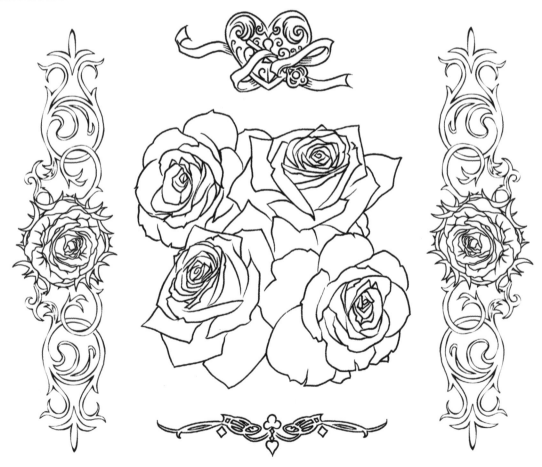

Top: *Traditional 042*
Center: *Traditional 053*
Lower: *Traditional 042*
Sides: *Traditional 036*

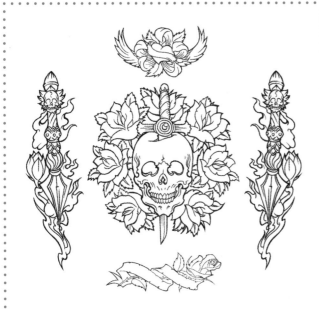

Top: *Traditional 031* **Center:** *Traditional 024*
Lower: *Traditional 018* **Sides:** *Traditional 028*

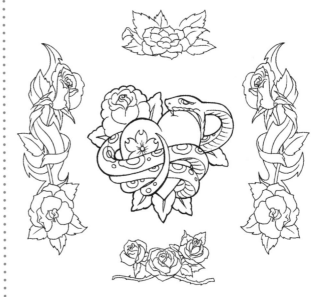

Top: *Traditional 037* **Center:** *Traditional 059*
Lower: *Traditional 037* **Sides:** *Traditional 037*

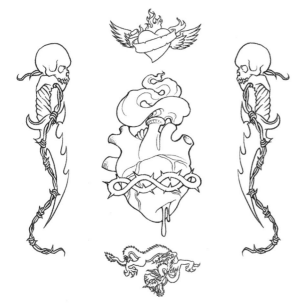

Top: *Traditional 017* **Center:** *Traditional 018*
Lower: *Traditional 002* **Sides:** *Traditional 015*

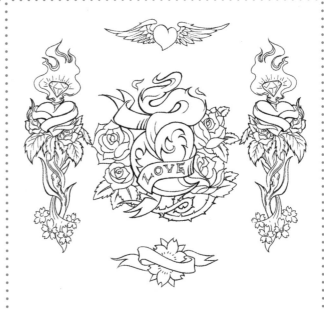

Top: *Traditional 003* **Center:** *Traditional 028*
Lower: *Traditional 002* **Sides:** *Traditional 008*

43

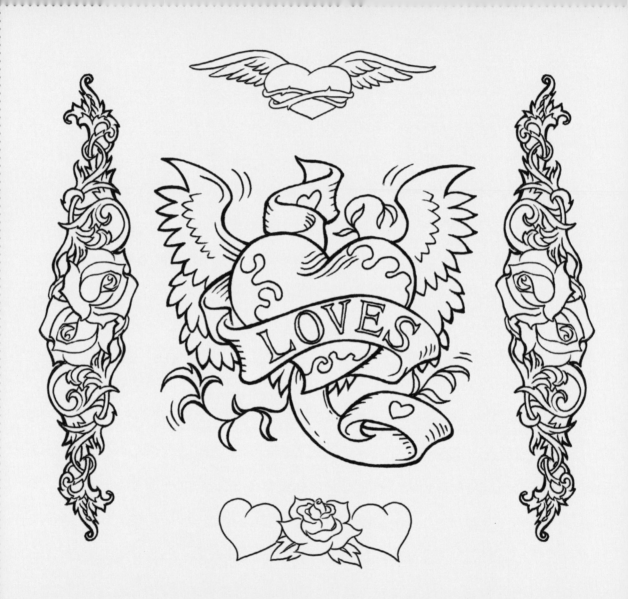

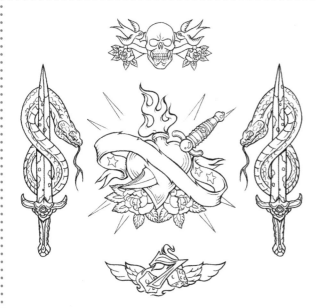

Top: *Traditional 026* **Center:** *Traditional 031*
Lower: *Traditional 021* **Sides:** *Traditional 001*

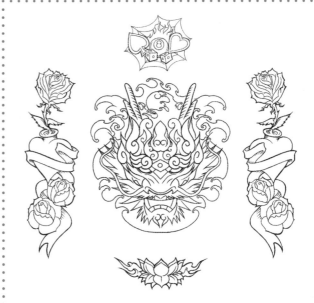

Top: *Traditional 021* **Center:** *Traditional 002*
Lower: *Traditional 028* **Sides:** *Traditional 029*

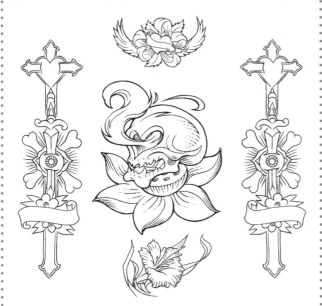

Top: *Traditional 031* **Center:** *Traditional 019*
Lower: *Traditional 008* **Sides:** *Traditional 026*

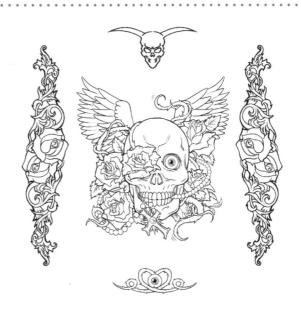

Top: *Traditional 001* **Center:** *Traditional 025*
Lower: *Traditional 025* **Sides:** *Traditional 024*

Traditional

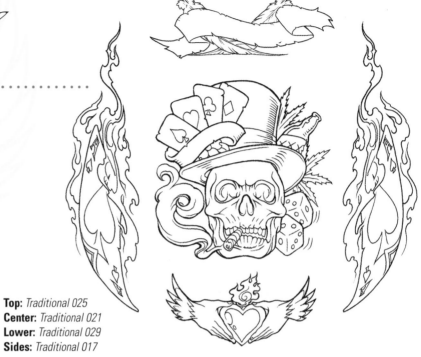

Top: *Traditional 025*
Center: *Traditional 021*
Lower: *Traditional 029*
Sides: *Traditional 017*

Top: *Traditional 013* **Center:** *Traditional 026*
Lower: *Traditional 015* **Sides:** *Traditional 021*

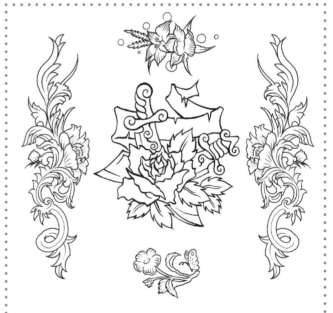

Top: *Traditional 040* **Center:** *Traditional 055*
Lower: *Traditional 040* **Sides:** *Traditional 040*

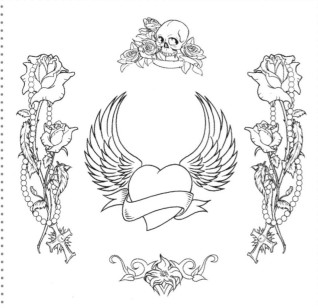

Top: *Traditional 019* **Center:** *Traditional 017*
Lower: *Traditional 013* **Sides:** *Traditional 025*

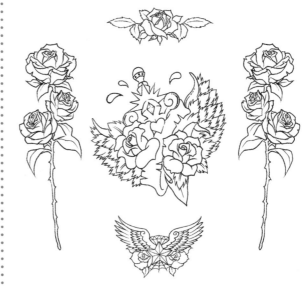

Top: *Traditional 038* **Center:** *Traditional 052*
Lower: *Traditional 038* **Sides:** *Traditional 038*

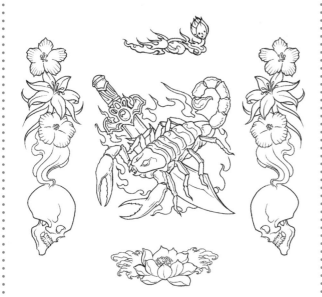

Top: *Traditional 028* **Center:** *Traditional 008*
Lower: *Traditional 019* **Sides:** *Traditional 013*

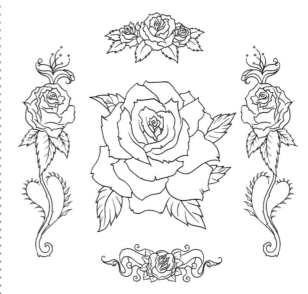

Top: *Traditional 041* **Center:** *Traditional 056*
Lower: *Traditional 039* **Sides:** *Traditional 039*

Traditional

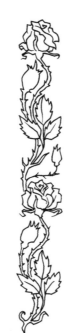

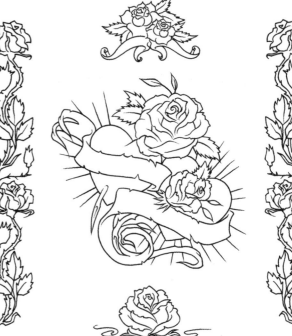

Top: *Traditional 039*
Center: *Traditional 054*
Lower: *Traditional 041*
Sides: *Traditional 041*

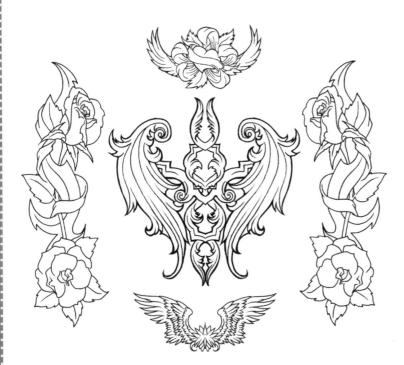

Top: *Traditional 031*
Center: *Traditional 044*
Lower: *Traditional 017*
Sides: *Traditional 037*

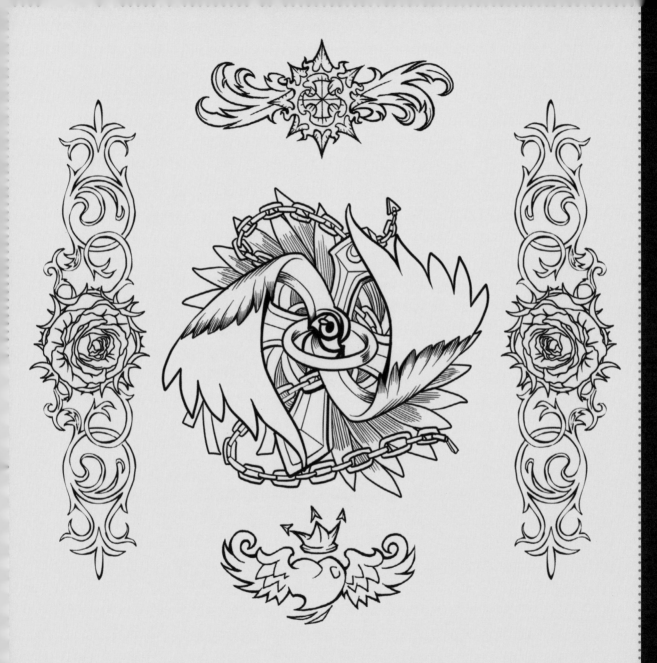

Top: *Traditional 034* **Center:** *Traditional 050*
Lower: *Traditional 034* **Sides:** *Traditional 036*

Traditional

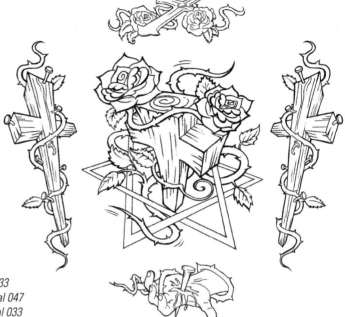

Top: *Traditional 033*
Center: *Traditional 047*
Lower: *Traditional 033*
Sides: *Traditional 033*

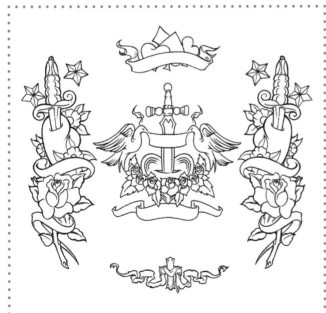

Top: *Traditional 032* **Center:** *Traditional 060*
Lower: *Traditional 032* **Sides:** *Traditional 032*

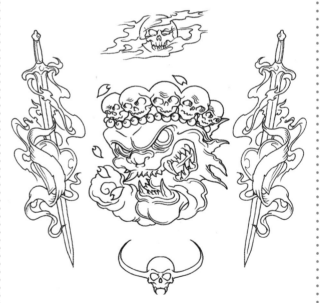

Top: *Traditional 015* **Center:** *Traditional 001*
Lower: *Traditional 001* **Sides:** *Traditional 008*

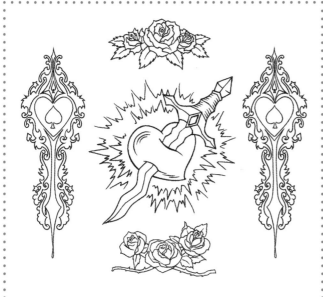

Top: *Traditional 041* **Center:** *Traditional 061*
Lower: *Traditional 037* **Sides:** *Traditional 042*

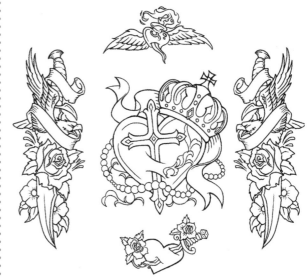

Top: *Traditional 044* **Center:** *Traditional 062*
Lower: *Traditional 044* **Sides:** *Traditional 043*

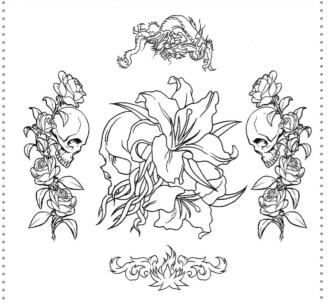

Top: *Traditional 002* **Center:** *Traditional 013*
Lower: *Traditional 003* **Sides:** *Traditional 019*

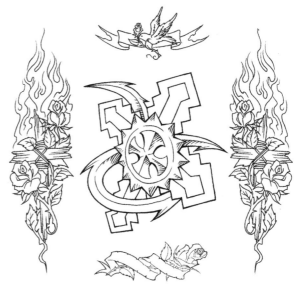

Top: *Traditional 035* **Center:** *Traditional 048*
Lower: *Traditional 018* **Sides:** *Traditional 035*

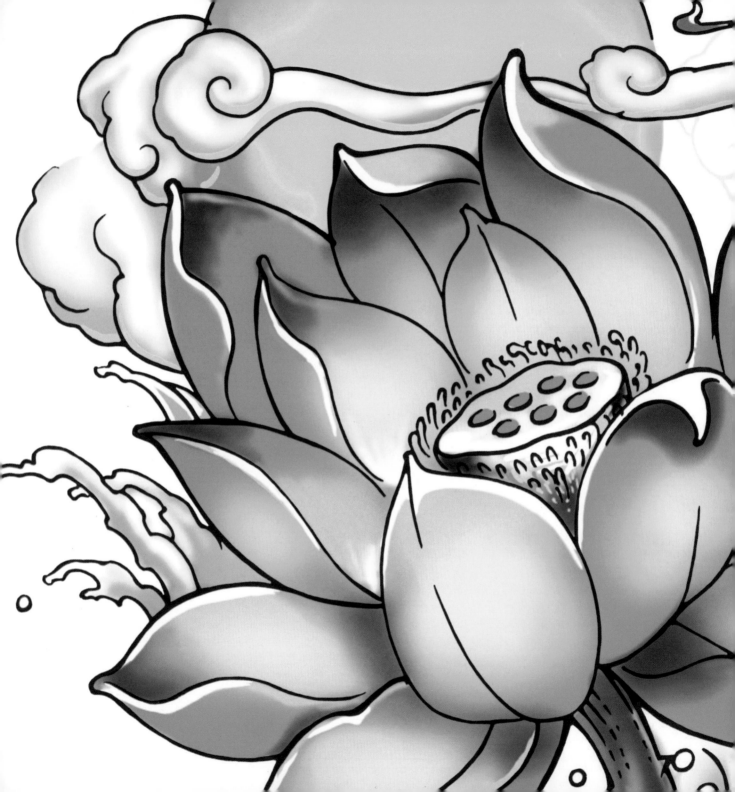

Asian

Asian

Dragons, demons, Buddhas, lotuses, blossoms, and koi feature heavily in Asian tattoo designs. Many of these subjects can also be found in other sections, and so these motifs are highly versatile. Asian tattoos are very popular today due to their elegant style; experimenting with some of the many possible combinations will help you design a modern tattoo that's truly unique.

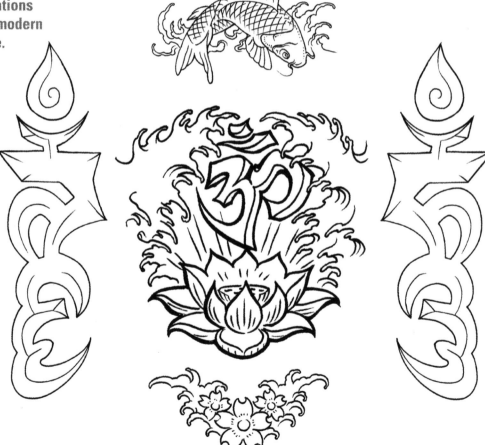

Top: *Asian 001*
Center: *Asian 017*
Lower: *Asian 010*
Sides: *Asian 011*

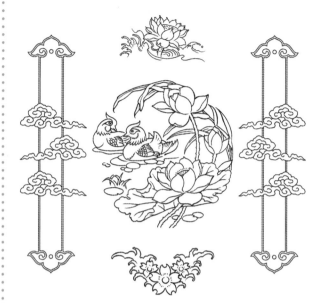

Top: *Asian 002* **Center:** *Asian 004*
Lower: *Asian 010* **Sides:** *Asian 007*

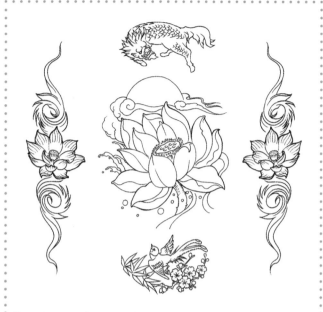

Top: *Asian 005* **Center:** *Asian 002*
Lower: *Asian 004* **Sides:** *Asian 008*

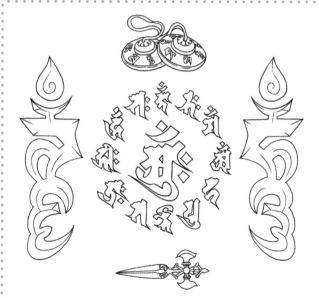

Top: *Asian 011* **Center:** *Asian 023*
Lower: *Asian 011* **Sides:** *Asian 011*

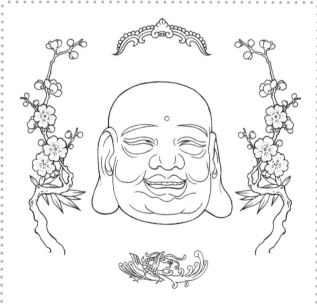

Top: *Asian 009* **Center:** *Asian 009*
Lower: *Asian 003* **Sides:** *Asian 004*

Top: *Asian 007* **Center:** *Asian 006*
Lower: *Asian 005* **Sides:** *Asian 010*

Top: *Asian 006* **Center:** *Asian 005*
Lower: *Asian 006* **Sides:** *Asian 002*

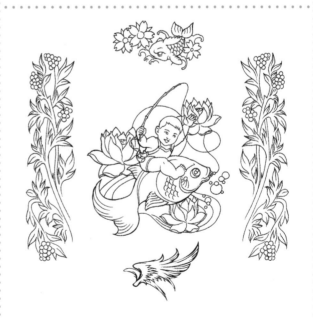

Top: *Asian 001* **Center:** *Asian 003*
Lower: *Asian 002* **Sides:** *Asian 004*

Top: *Asian 010* **Center:** *Asian 001*
Lower: *Asian 007* **Sides:** *Asian 003*

Asian

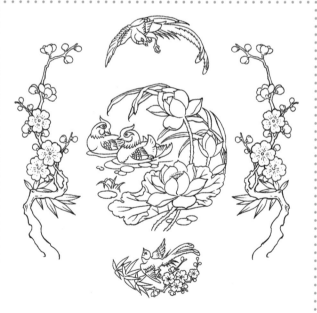

Top: *Asian 010*
Center: *Asian 023*
Lower: *Asian 004*
Sides: *Asian 001*

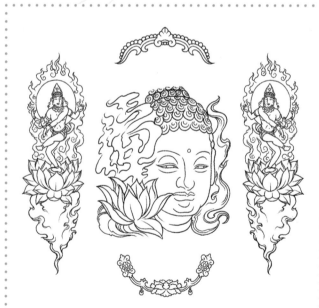

Top: *Asian 009* **Center:** *Asian 010*
Lower: *Asian 009* **Sides:** *Asian 009*

Top: *Asian 004* **Center:** *Asian 004*
Lower: *Asian 004* **Sides:** *Asian 004*

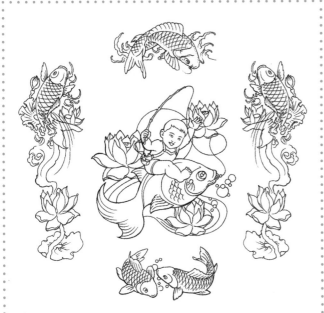

Top: *Asian 001* **Center:** *Asian 001*
Lower: *Asian 001* **Sides:** *Asian 001*

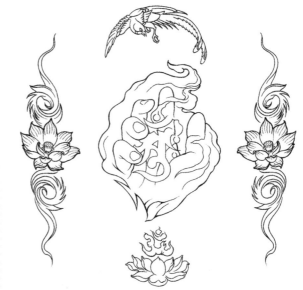

Top: *Asian 004* **Center:** *Asian 022*
Lower: *Asian 002* **Sides:** *Asian 008*

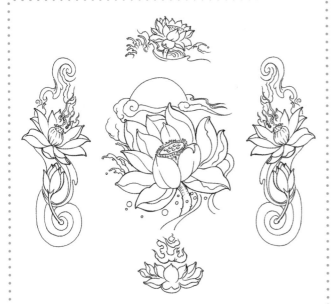

Top: *Asian 002* **Center:** *Asian 002*
Lower: *Asian 002* **Sides:** *Asian 002*

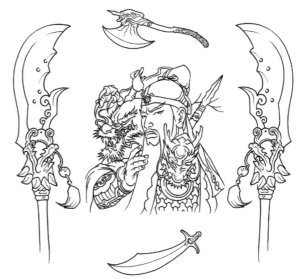

Top: *Asian 006* **Center:** *Asian 006*
Lower: *Asian 006* **Sides:** *Asian 006*

Asian

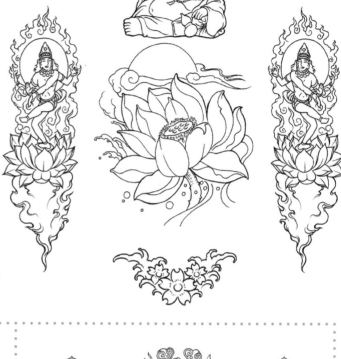

Top: *Asian 008*
Center: *Asian 002*
Lower: *Asian 010*
Sides: *Asian 009*

Top: *Asian 007* **Center:** *Asian 031 (Ram)*
Lower: *Asian 008* **Sides:** *Asian 005*

Top: *Asian 003* **Center:** *Asian 017*
Lower: *Asian 003* **Sides:** *Asian 007*

Top: *Asian 002* **Center:** *Asian 034 (Snake)*
Lower: *Asian 002* **Sides:** *Asian 004*

Top: *Asian 005* **Center:** *Asian 005*
Lower: *Asian 005* **Sides:** *Asian 005*

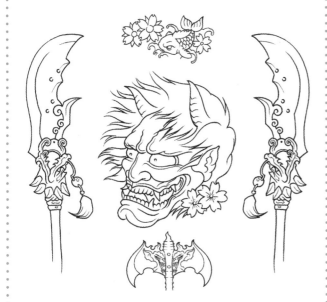

Top: *Asian 010* **Center:** *Asian 012*
Lower: *Asian 005* **Sides:** *Asian 006*

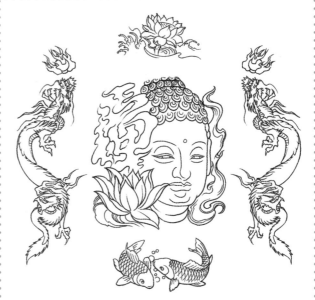

Top: *Asian 002* **Center:** *Asian 010*
Lower: *Asian 001* **Sides:** *Asian 005*

Mythical

Mythical

Fire-breathing dragons and romantic fairies abound in these bold mythical tattoo designs. Both have connotations of fantasy or spirituality; dragons often also denote power and strength, while fairies can signify beauty. Soften a dragon motif with feminine elements, or turn fairy into femme fatale with some edgy horror pieces.

Top: *Mythical 006*
Center: *Mythical 001*
Lower: *Mythical 002*
Sides: *Mythical 005*

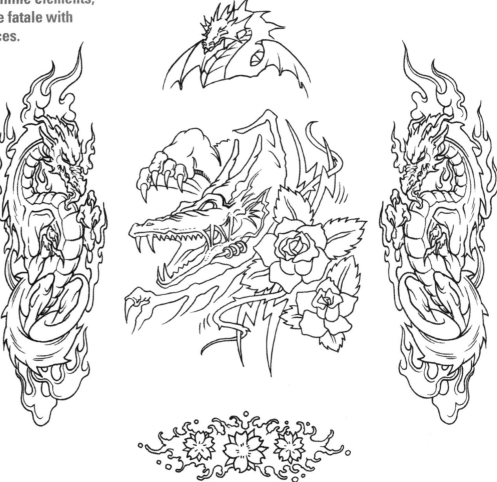

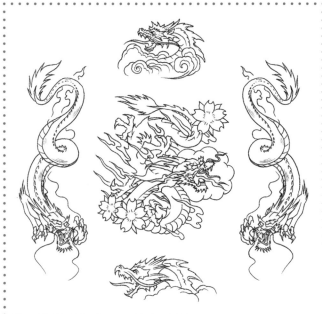

Top: *Mythical 005* **Center:** *Mythical 002*
Lower: *Mythical 001* **Sides:** *Mythical 006*

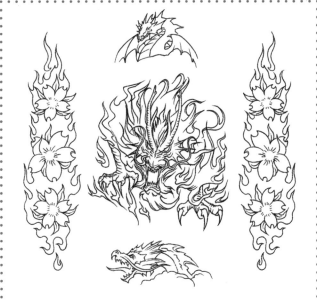

Top: *Mythical 006* **Center:** *Mythical 005*
Lower: *Mythical 001* **Sides:** *Mythical 002*

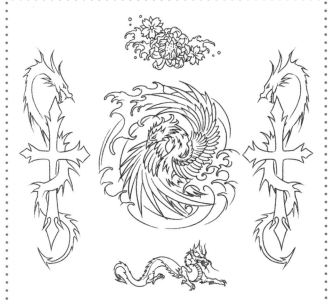

Top: *Mythical 002* **Center:** *Mythical 006*
Lower: *Mythical 005* **Sides:** *Mythical 001*

Top: *Mythical 004* **Center:** *Mythical 003*
Lower: *Mythical 003* **Sides:** *Mythical 004*

Top: *Mythical 001* **Center:** *Mythical 004*
Lower: *Mythical 005* **Sides:** *Mythical 002*

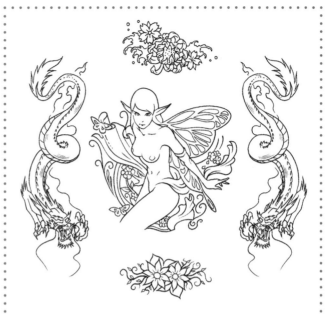

Top: *Mythical 002* **Center:** *Mythical 003*
Lower: *Mythical 003* **Sides:** *Mythical 006*

Top: *Mythical 001* **Center:** *Mythical 006*
Lower: *Mythical 002* **Sides:** *Mythical 004*

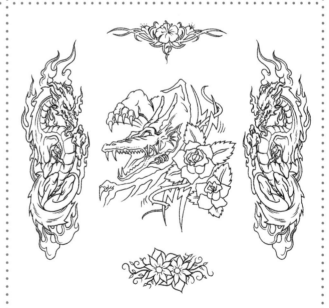

Top: *Mythical 004* **Center:** *Mythical 001*
Lower: *Mythical 003* **Sides:** *Mythical 005*

Mythical

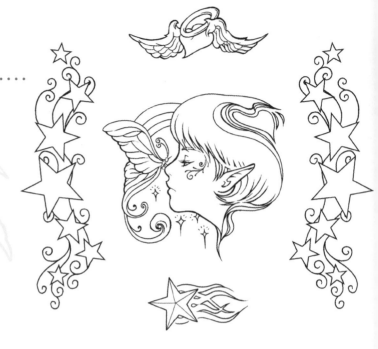

Top: *Mythical 009*
Center: *Mythical 014*
Lower: *Mythical 007*
Sides: *Mythical 008*

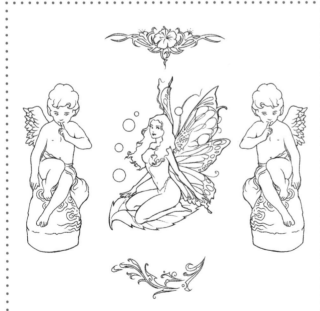

Top: *Mythical 004* **Center:** *Mythical 012*
Lower: *Mythical 004* **Sides:** *Mythical 010*

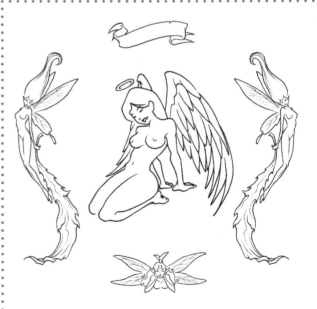

Top: *Mythical 012* **Center:** *Mythical 022*
Lower: *Mythical 009* **Sides:** *Mythical 009*

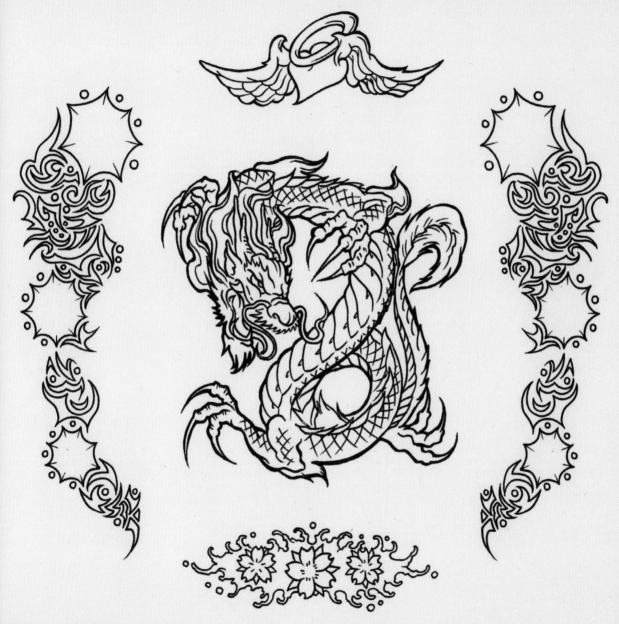

Top: *Mythical 009* **Center:** *Mythical 009*
Lower: *Mythical 002* **Sides:** *Mythical 007*

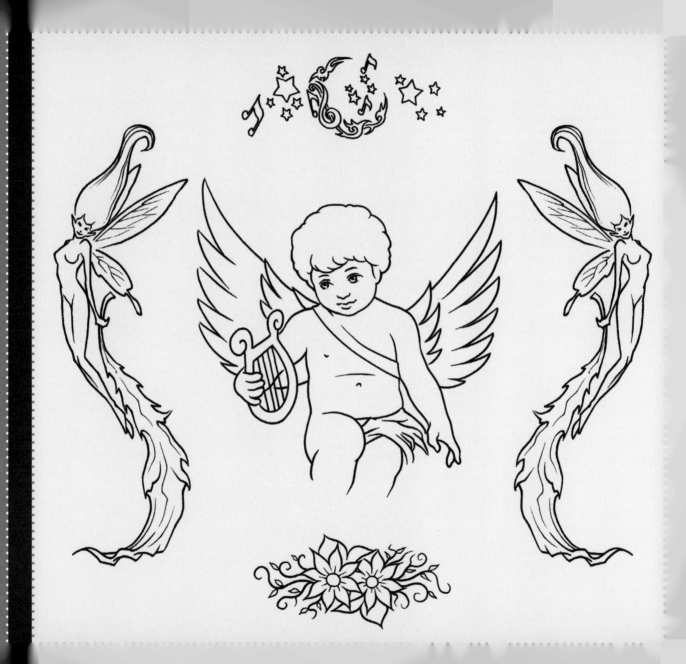

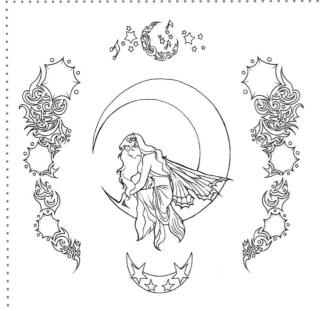

Top: *Mythical 008* **Center:** *Mythical 018*
Lower: *Mythical 008* **Sides:** *Mythical 007*

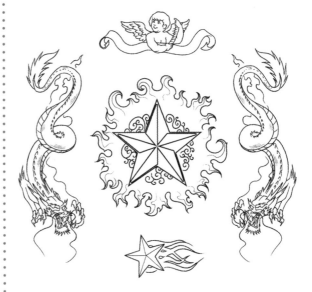

Top: *Mythical 011* **Center:** *Mythical 016*
Lower: *Mythical 007* **Sides:** *Mythical 006*

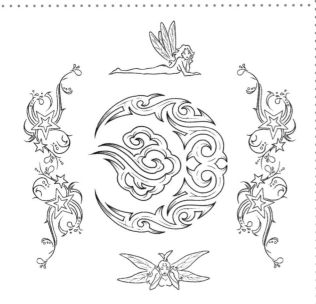

Top: *Mythical 010* **Center:** *Mythical 015*
Lower: *Mythical 009* **Sides:** *Mythical 003*

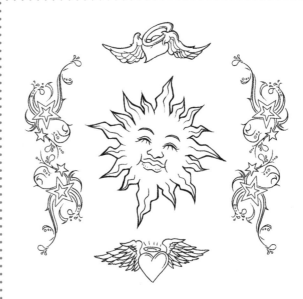

Top: *Mythical 009* **Center:** *Mythical 019*
Lower: *Mythical 011* **Sides:** *Mythical 003*

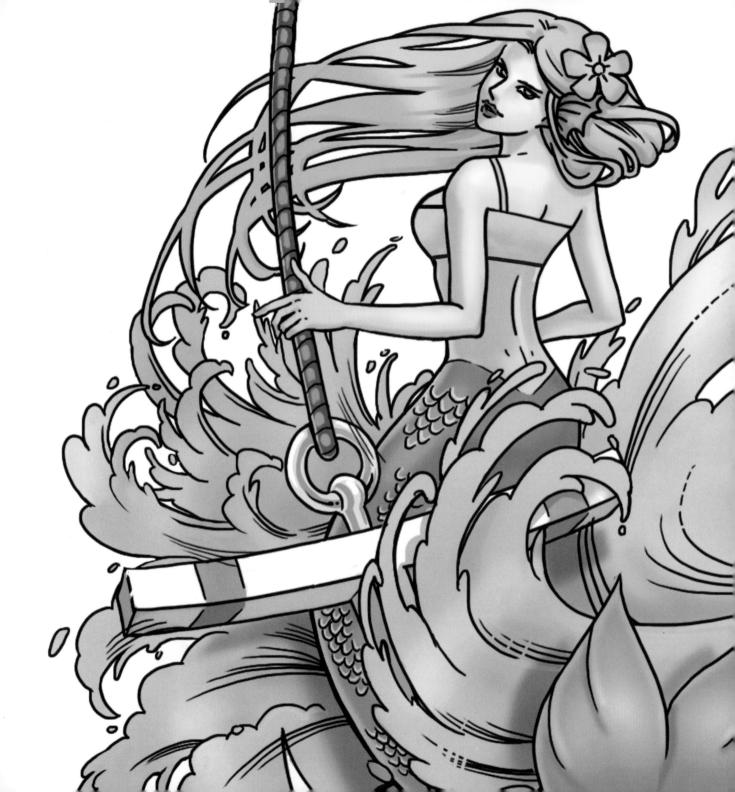

Nautical

Nautical

The seafarer's design of choice!
Nautical tattoos also fall under the
traditional banner, as sailors were
among the first modern people to
practice the art of tattooing.

Top: *Nautical 003*
Center: *Nautical 005*
Lower: *Nautical 006*
Sides: *Nautical 004*

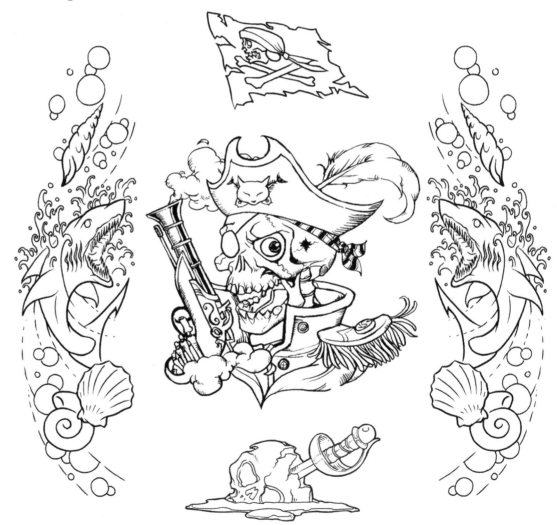

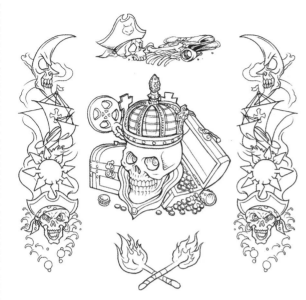

Top: *Nautical 005* **Center:** *Nautical 006*
Lower: *Nautical 004* **Sides:** *Nautical 003*

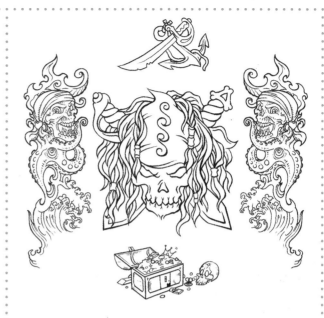

Top: *Nautical 004* **Center:** *Nautical 003*
Lower: *Nautical 005* **Sides:** *Nautical 006*

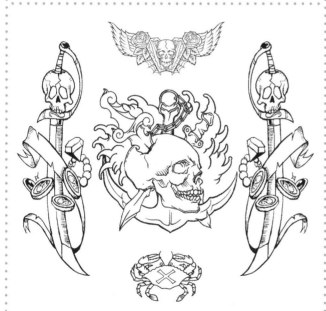

Top: *Nautical 006* **Center:** *Nautical 004*
Lower: *Nautical 003* **Sides:** *Nautical 005*

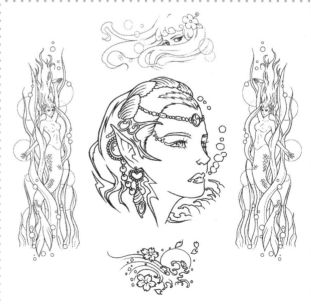

Top: *Nautical 001* **Center:** *Nautical 002*
Lower: *Nautical 002* **Sides:** *Nautical 001*

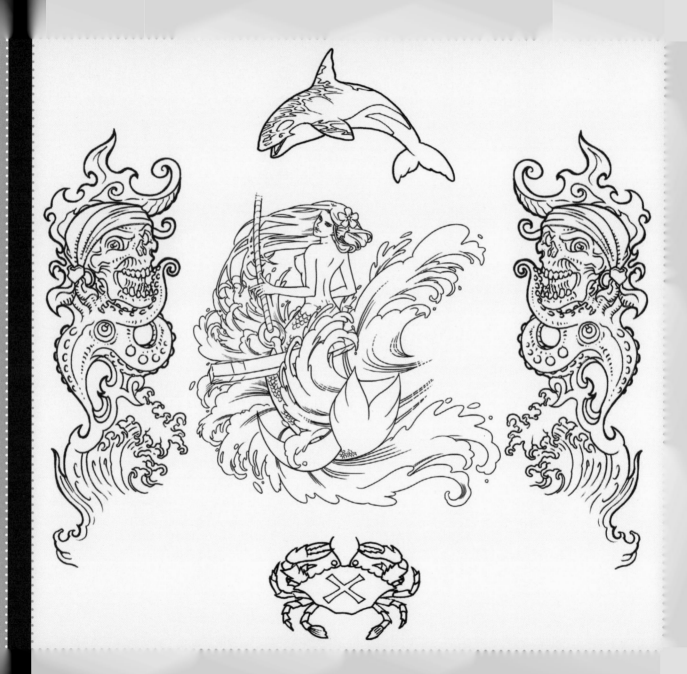

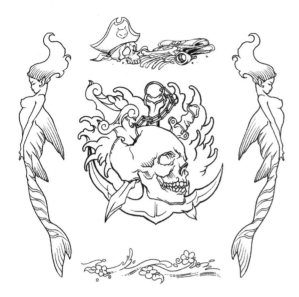

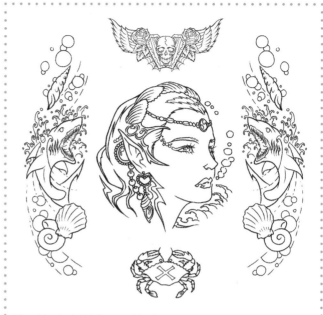

Top: *Nautical 005* **Center:** *Nautical 004*
Lower: *Nautical 001* **Sides:** *Nautical 002*

Top: *Nautical 006* **Center:** *Nautical 002*
Lower: *Nautical 003* **Sides:** *Nautical 004*

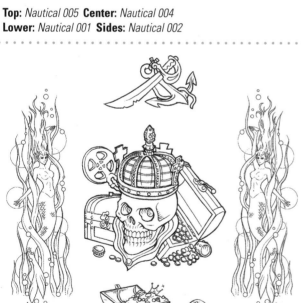

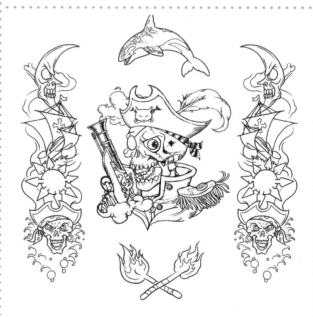

Top: *Nautical 004* **Center:** *Nautical 006*
Lower: *Nautical 005* **Sides:** *Nautical 001*

Top: *Nautical 002* **Center:** *Nautical 005*
Lower: *Nautical 004* **Sides:** *Nautical 003*

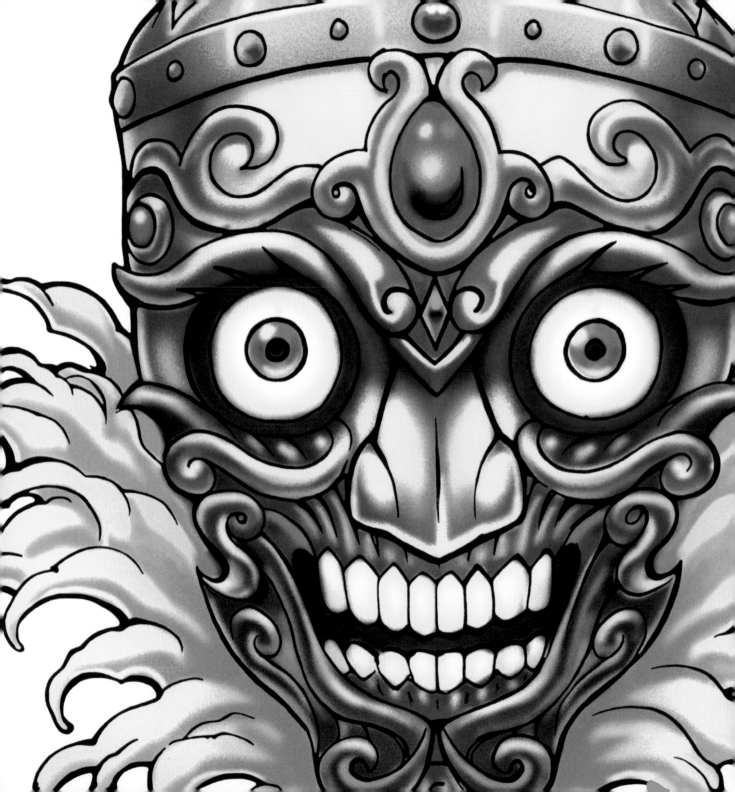

Tribal

Tribal

Tribal tattoos represent culture and affiliations, whether symbolically or thematically. Here are a range of tribal designs, with Native American, Egyptian, Celtic, and Asian motifs.

Top: *Tribal 009*
Center: *Tribal 026*
Lower: *Tribal 009*
Sides: *Tribal 018*

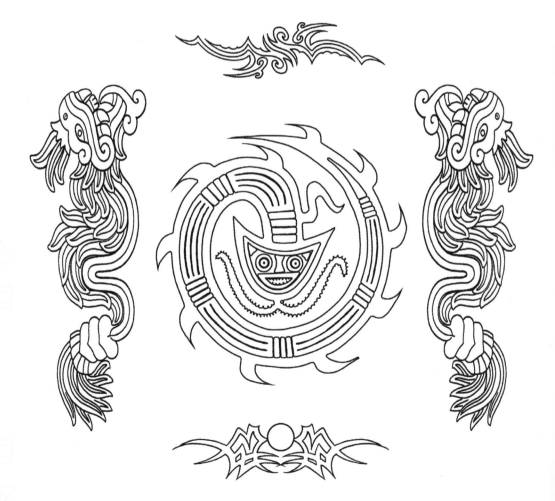

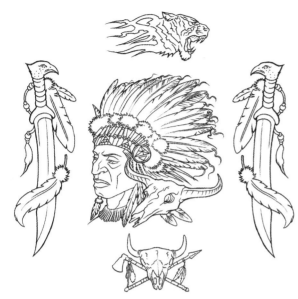

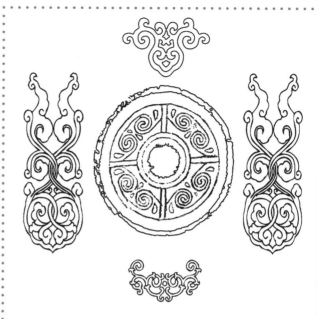

Top: *Tribal 005* **Center:** *Tribal 002*
Lower: *Tribal 004* **Sides:** *Tribal 003*

Top: *Tribal 013* **Center:** *Tribal 020*
Lower: *Tribal 013* **Sides:** *Tribal 013*

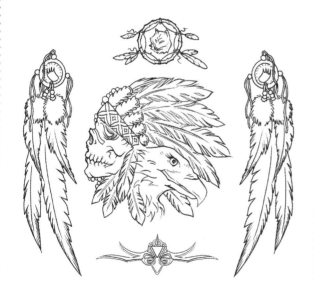

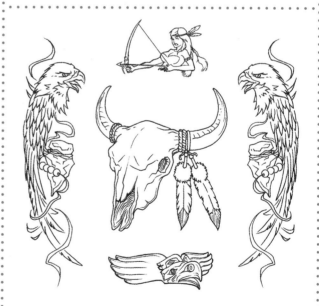

Top: *Tribal 003* **Center:** *Tribal 004*
Lower: *Tribal 001* **Sides:** *Tribal 005*

Top: *Tribal 002* **Center:** *Tribal 005*
Lower: *Tribal 003* **Sides:** *Tribal 006*

Tribal

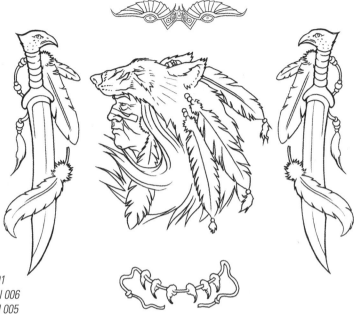

Top: *Tribal 001*
Center: *Tribal 006*
Lower: *Tribal 005*
Sides: *Tribal 003*

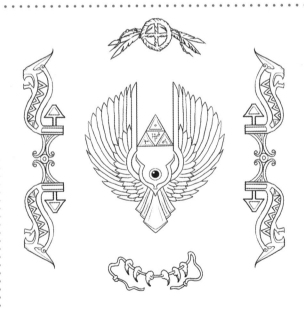

Top: *Tribal 006* **Center:** *Tribal 001*
Lower: *Tribal 005* **Sides:** *Tribal 001*

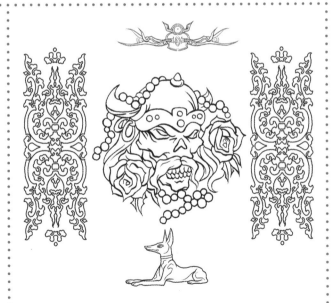

Top: *Tribal 011* **Center:** *Tribal 009*
Lower: *Tribal 008* **Sides:** *Tribal 010*

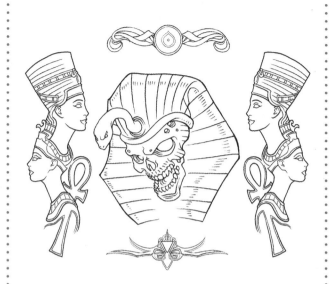

Top: *Tribal 012* **Center:** *Tribal 007*
Lower: *Tribal 001* **Sides:** *Tribal 008*

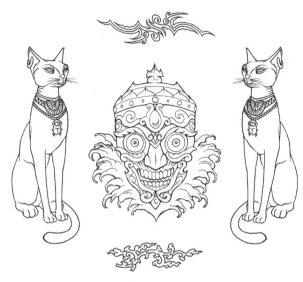

Top: *Tribal 009* **Center:** *Tribal 013*
Lower: *Tribal 010* **Sides:** *Tribal 007*

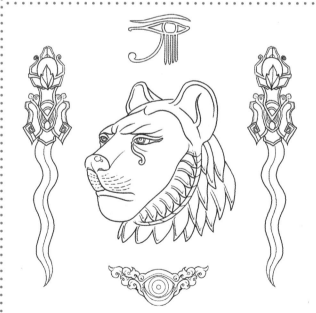

Top: *Tribal 007* **Center:** *Tribal 008*
Lower: *Tribal 012* **Sides:** *Tribal 011*

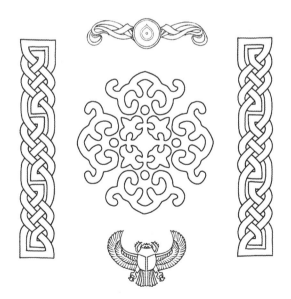

Top: *Tribal 012* **Center:** *Tribal 010*
Lower: *Tribal 007* **Sides:** *Tribal 009*

Tribal

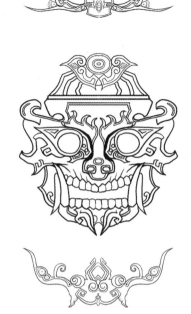

Top: *Tribal 011*
Center: *Tribal 011*
Lower: *Tribal 011*
Sides: *Tribal 009*

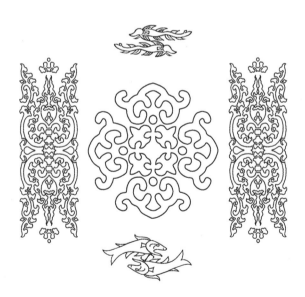

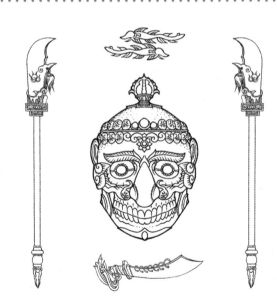

Top: *Tribal 019* **Center:** *Tribal 010*
Lower: *Tribal 019* **Sides:** *Tribal 010*

Top: *Tribal 019* **Center:** *Tribal 019*
Lower: *Tribal 020* **Sides:** *Tribal 020*

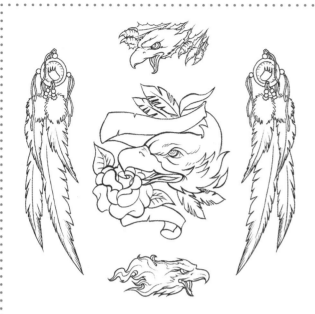

Top: *Tribal 015* **Center:** *Tribal 023*
Lower: *Tribal 015* **Sides:** *Tribal 005*

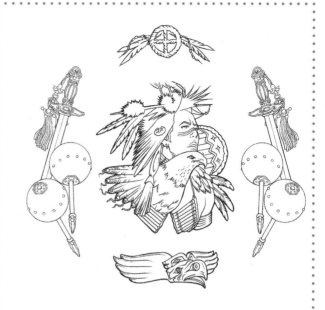

Top: *Tribal 006* **Center:** *Tribal 003*
Lower: *Tribal 003* **Sides:** *Tribal 021*

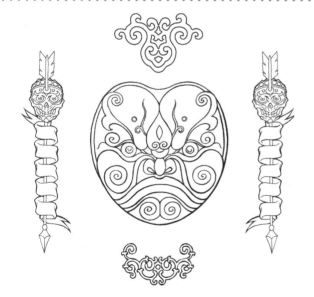

Top: *Tribal 013* **Center:** *Tribal 012*
Lower: *Tribal 013* **Sides:** *Tribal 012*

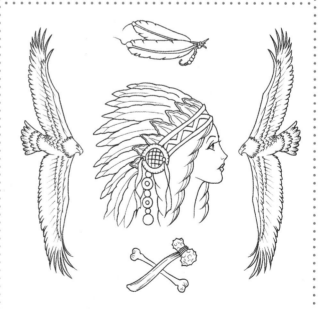

Top: *Tribal 016* **Center:** *Tribal 024*
Lower: *Tribal 016* **Sides:** *Tribal 015*

Tribal

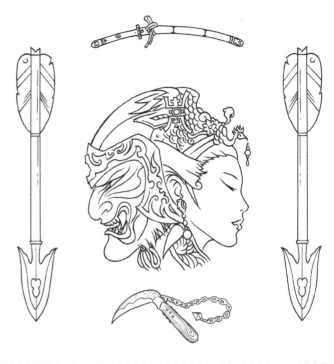

Top: *Tribal 014*
Center: *Tribal 021*
Lower: *Tribal 014*
Sides: *Tribal 014*

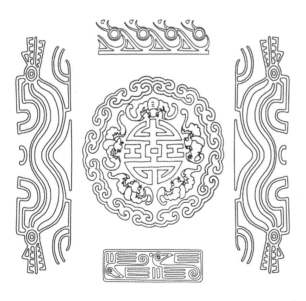

Top: *Tribal 018* **Center:** *Tribal 022*
Lower: *Tribal 018* **Sides:** *Tribal 019*

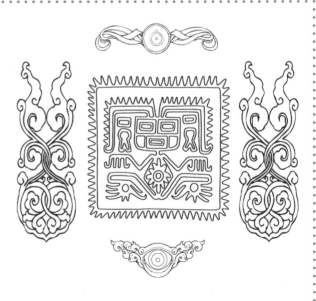

Top: *Tribal 012* **Center:** *Tribal 027*
Lower: *Tribal 012* **Sides:** *Tribal 013*

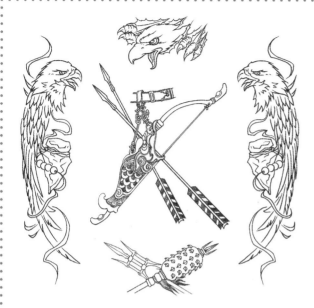

Top: *Tribal 015* **Center:** *Tribal 029*
Lower: *Tribal 021* **Sides:** *Tribal 006*

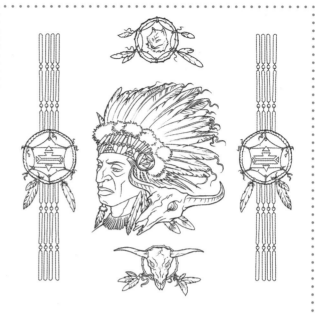

Top: *Tribal 003* **Center:** *Tribal 002*
Lower: *Tribal 002* **Sides:** *Tribal 002*

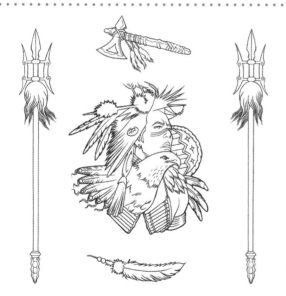

Top: *Tribal 017* **Center:** *Tribal 003*
Lower: *Tribal 006* **Sides:** *Tribal 022*

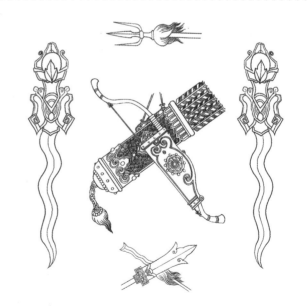

Top: *Tribal 022* **Center:** *Tribal 030*
Lower: *Tribal 022* **Sides:** *Tribal 011*

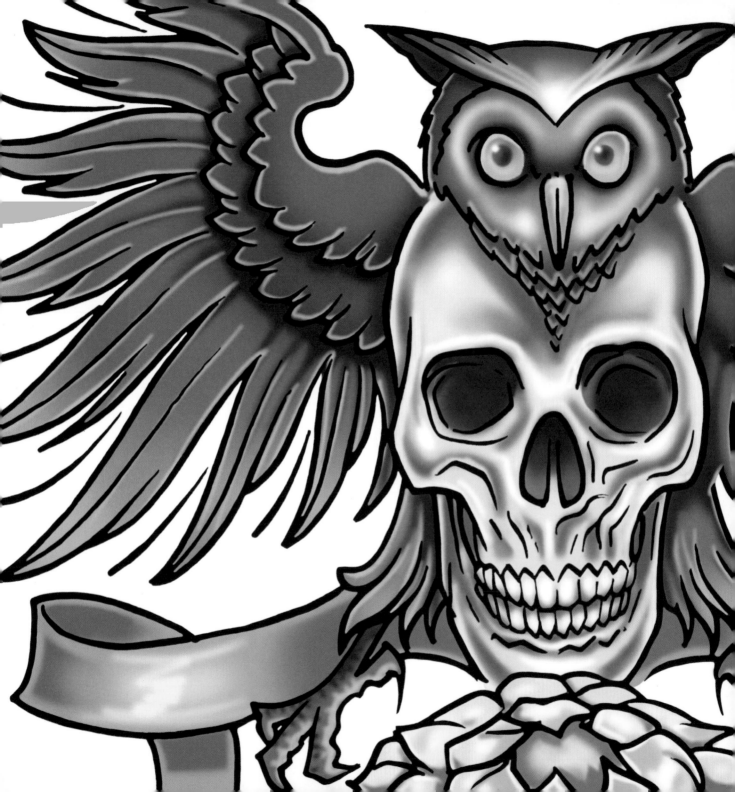

Horror

Horror

There are skulls, demons, and ghouls galore in this dark corner of the book. The horror genre has a huge following and this tattoo style draws influence from films, comics, and fiction novels. Often, horror fans will opt for a tattoo of a favored horror character or icon.

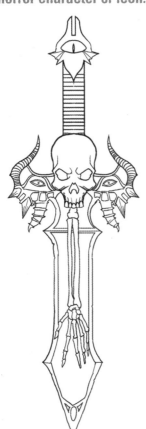
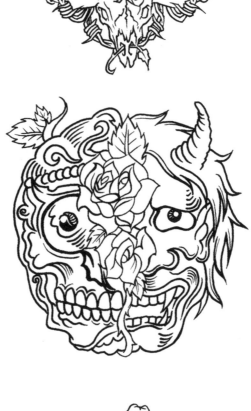
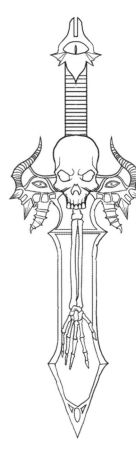

Top: *Horror 001*
Center: *Horror 004*
Lower: *Horror 007*
Sides: *Horror 010*

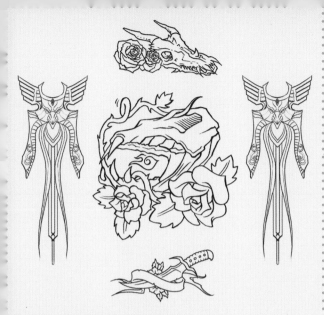

Top: *Horror 002* **Center:** *Horror 001*
Lower: *Horror 006* **Sides:** *Horror 012*

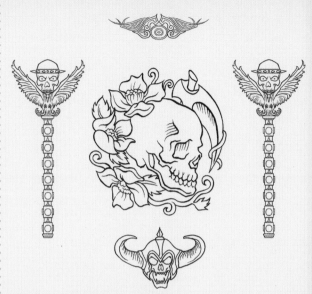

Top: *Horror 009* **Center:** *Horror 002*
Lower: *Horror 005* **Sides:** *Horror 011*

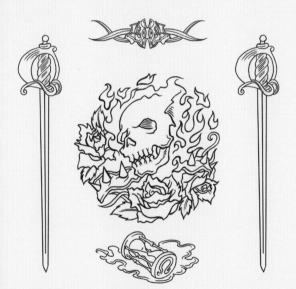

Top: *Horror 011* **Center:** *Horror 005*
Lower: *Horror 008* **Sides:** *Horror 009*

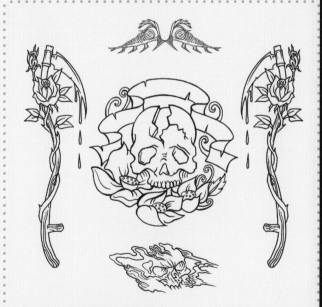

Top: *Horror 012* **Center:** *Horror 006*
Lower: *Horror 004* **Sides:** *Horror 008*

Horror

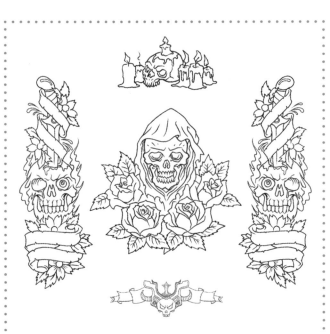

Top: *Horror 005*
Center: *Horror 007*
Lower: *Horror 009*
Sides: *Horror 007*

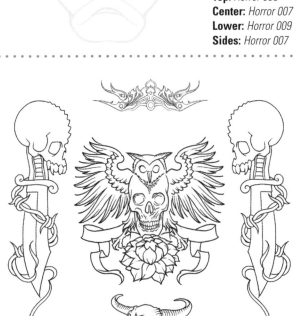

Top: *Horror 010* **Center:** *Horror 008*
Lower: *Horror 003* **Sides:** *Horror 006*

Top: *Horror 003* **Center:** *Horror 009*
Lower: *Horror 010* **Sides:** *Horror 005*

Top: *Horror 008* **Center:** *Horror 010*
Lower: *Horror 002* **Sides:** *Horror 004*

Top: *Horror 007* **Center:** *Horror 011*
Lower: *Horror 001* **Sides:** *Horror 003*

Top: *Horror 004* **Center:** *Horror 012*
Lower: *Horror 012* **Sides:** *Horror 002*

Top: *Horror 006* **Center:** *Horror 013*
Lower: *Horror 011* **Sides:** *Horror 013*

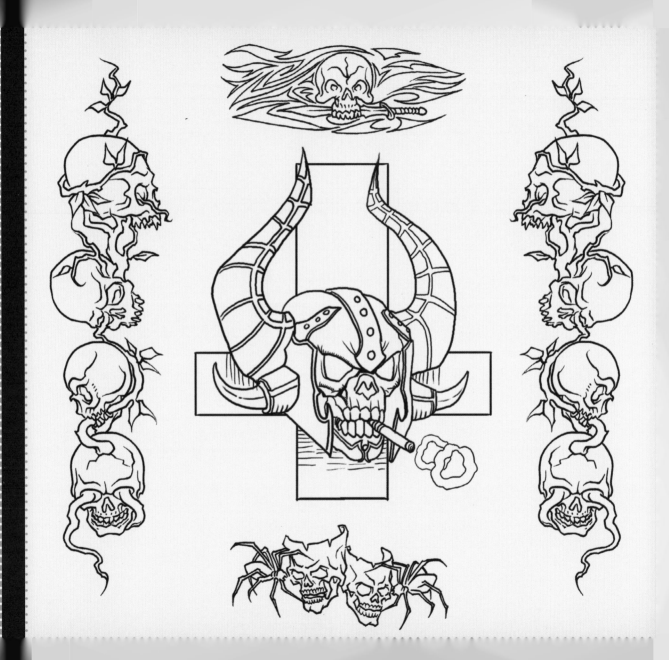

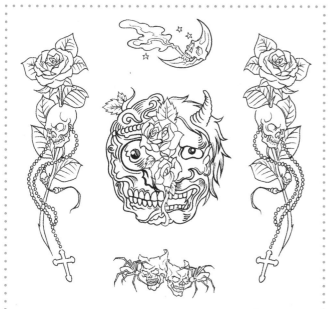

Top: *Horror 014* **Center:** *Horror 004*
Lower: *Horror 002* **Sides:** *Horror 007*

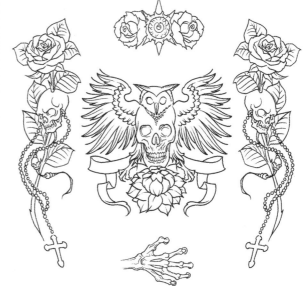

Top: *Horror 007* **Center:** *Horror 008*
Lower: *Horror 007* **Sides:** *Horror 007*

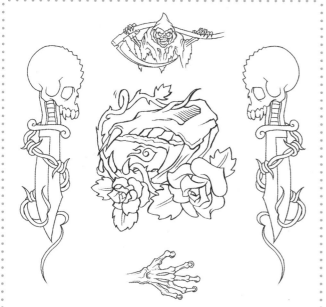

Top: *Horror 008* **Center:** *Horror 001*
Lower: *Horror 007* **Sides:** *Horror 006*

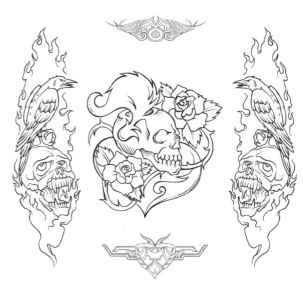

Top: *Horror 009* **Center:** *Horror 015*
Lower: *Horror 011* **Sides:** *Horror 004*

Horror

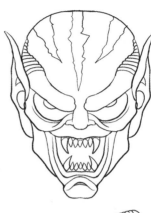

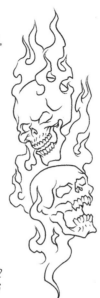

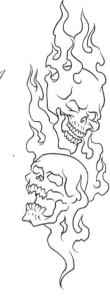

Top: *Horror 002*
Center: *Horror 012*
Lower: *Horror 006*
Sides: *Horror 001*

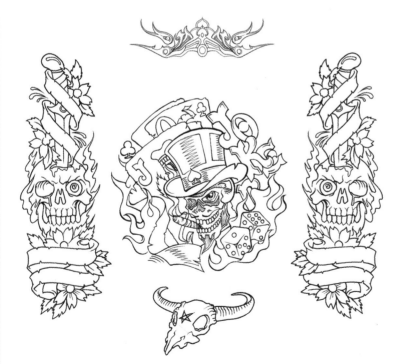

Top: *Horror 010*
Center: *Horror 007*
Lower: *Horror 003*
Sides: *Horror 005*

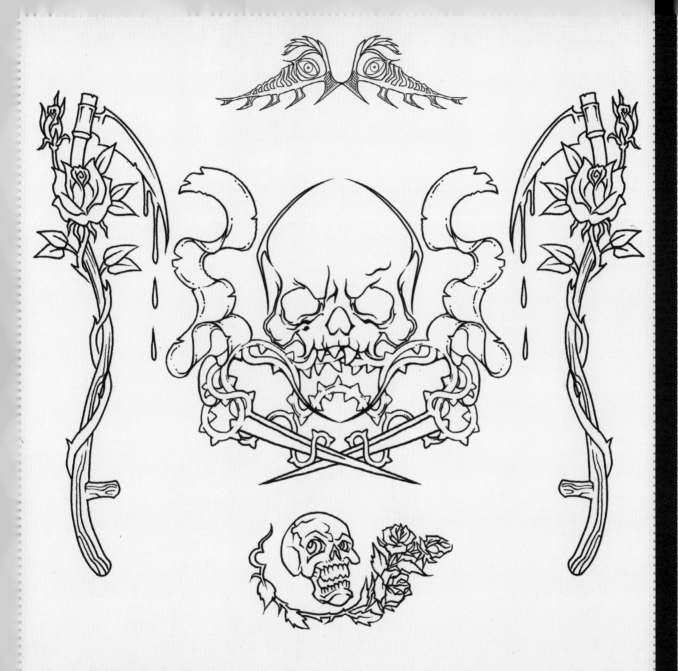

Top: *Horror 012* **Center:** *Horror 014*
Lower: *Horror 001* **Sides:** *Horror 008*

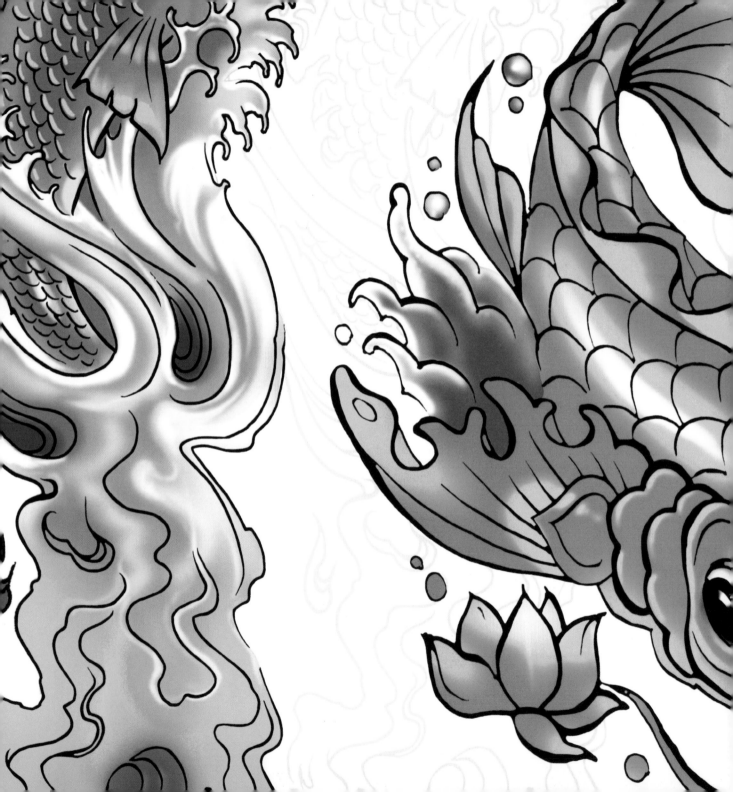

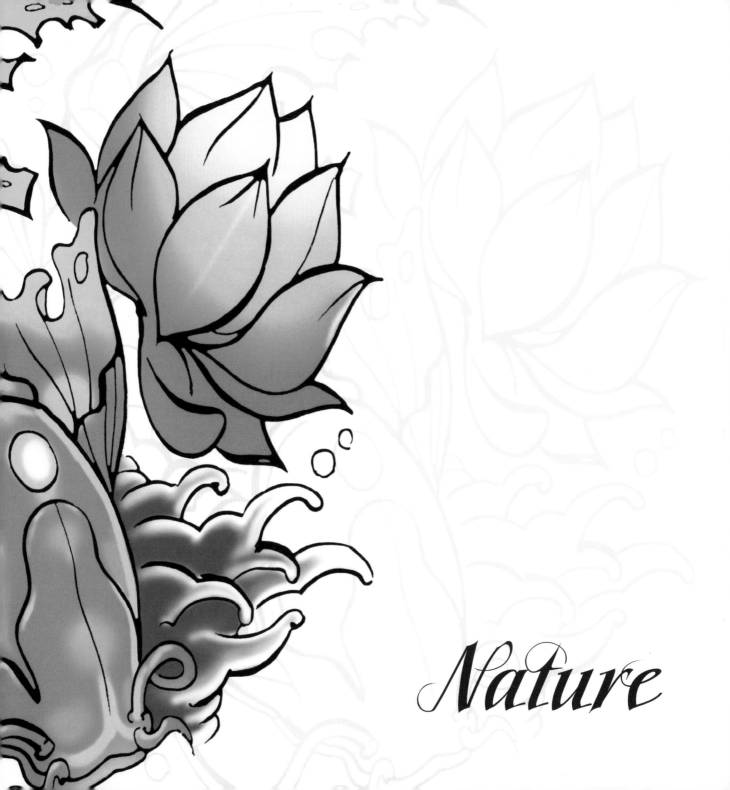

Nature

Nature

Nature tattoos can express a passion for the natural world, but they can also represent attributes of a person's character. Wolves and tigers, for example, can symbolize strength and bravery, while other animals can denote wisdom or loyalty. The koi is thought to be a symbol of luck and perseverance. Flowers also have meanings and are great for experimenting with colors: they can be bright and bold, or muted and dramatic.

Top: *Nature 024*
Center: *Nature 025*
Lower: *Nature 022*
Sides: *Nature 021*

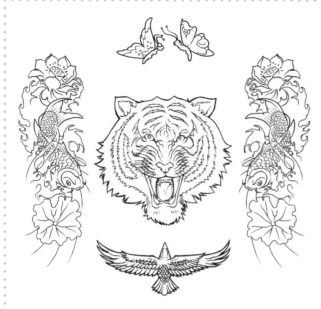

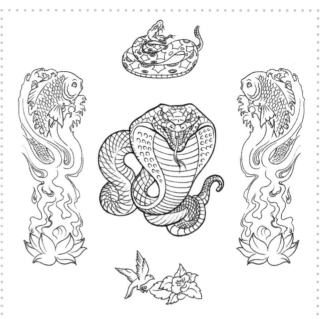

Top: *Nature 010* **Center:** *Nature 002*
Lower: *Nature 004* **Sides:** *Nature 017*

Top: *Nature 011* **Center:** *Nature 003*
Lower: *Nature 007* **Sides:** *Nature 016*

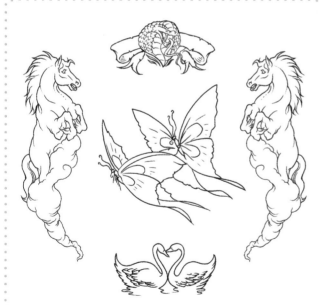

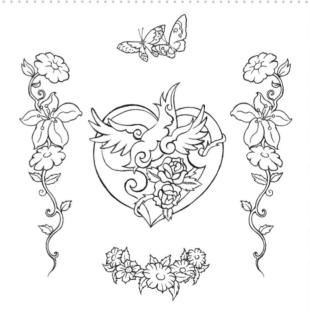

Top: *Nature 003* **Center:** *Nature 032*
Lower: *Nature 008* **Sides:** *Nature 026*

Top: *Nature 024* **Center:** *Nature 027*
Lower: *Nature 020* **Sides:** *Nature 022*

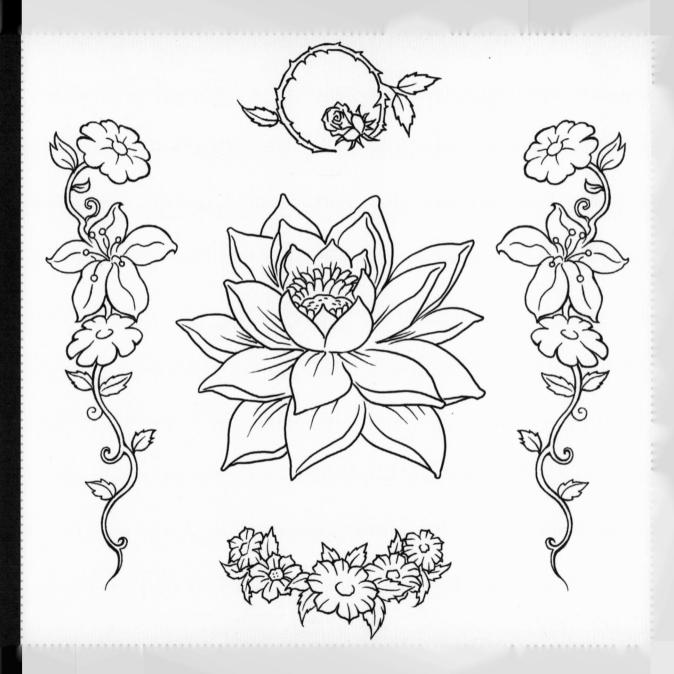

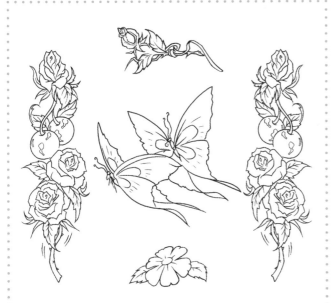

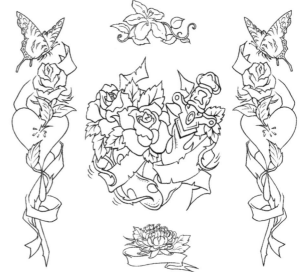

Top: *Nature 019* **Center:** *Nature 032*
Lower: *Nature 022* **Sides:** *Nature 020*

Top: *Nature 022* **Center:** *Nature 029*
Lower: *Nature 024* **Sides:** *Nature 019*

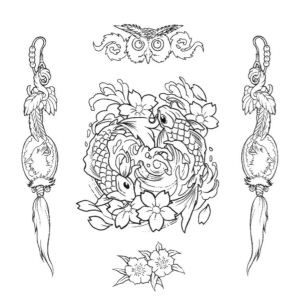

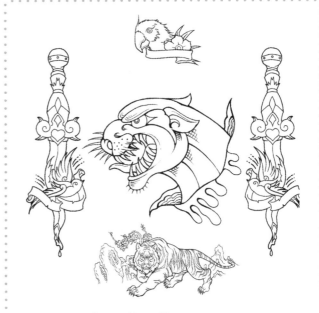

Top: *Nature 006* **Center:** *Nature 015*
Lower: *Nature 009* **Sides:** *Nature 005*

Top: *Nature 009* **Center:** *Nature 001*
Lower: *Nature 002* **Sides:** *Nature 018*

Nature

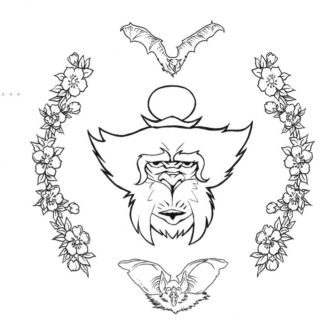

Top: *Nature 025*
Center: *Nature 033*
Lower: *Nature 025*
Sides: *Nature 023*

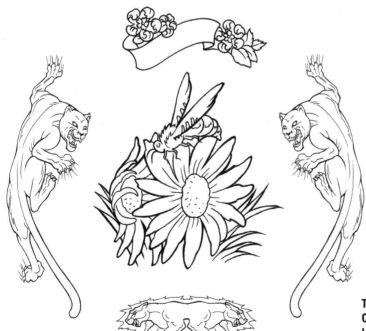

Top: *Nature 008*
Center: *Nature 023*
Lower: *Nature 001*
Sides: *Nature 001*

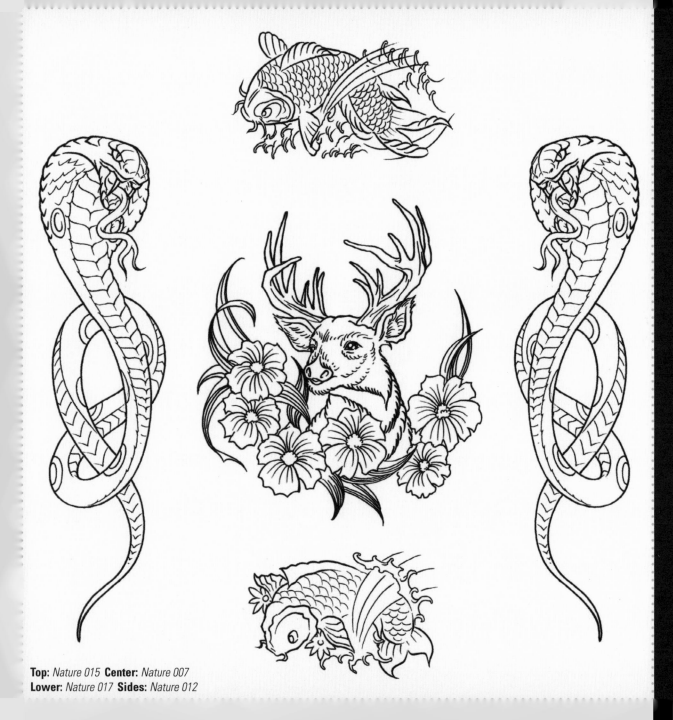

Top: *Nature 015* **Center:** *Nature 007*
Lower: *Nature 017* **Sides:** *Nature 012*

Nature

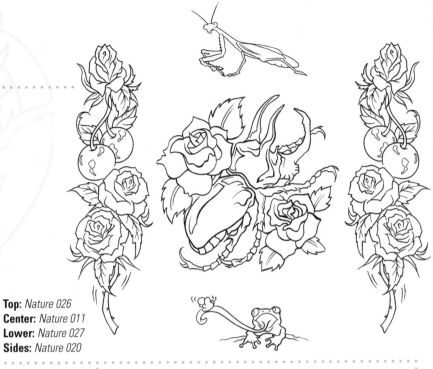

Top: *Nature 026*
Center: *Nature 011*
Lower: *Nature 027*
Sides: *Nature 020*

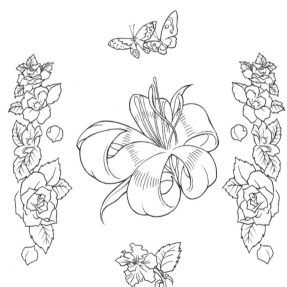

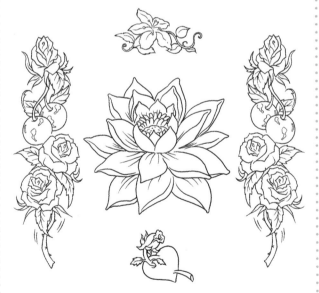

Top: *Nature 024* **Center:** *Nature 030*
Lower: *Nature 023* **Sides:** *Nature 021*

Top: *Nature 022* **Center:** *Nature 031*
Lower: *Nature 021* **Sides:** *Nature 020*

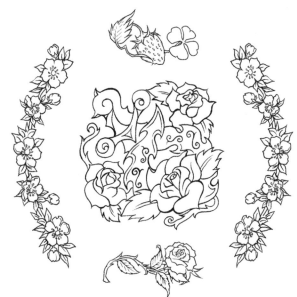

Top: *Nature 020* **Center:** *Nature 028*
Lower: *Nature 019* **Sides:** *Nature 023*

Top: *Nature 018* **Center:** *Nature 036*
Lower: *Nature 014* **Sides:** *Nature 025*

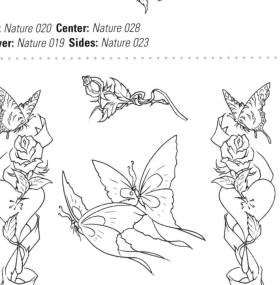

Top: *Nature 019* **Center:** *Nature 032*
Lower: *Nature 024* **Sides:** *Nature 019*

Top: *Nature 013* **Center:** *Nature 005*
Lower: *Nature 011* **Sides:** *Nature 014*

Top: *Nature 017* **Center:** *Nature 009*
Lower: *Nature 001* **Sides:** *Nature 010*

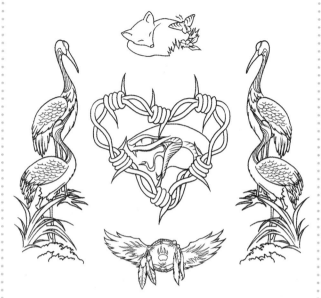

Top: *Nature 007* **Center:** *Nature 012*
Lower: *Nature 005* **Sides:** *Nature 008*

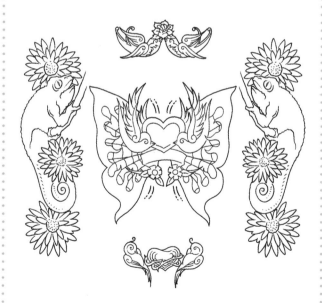

Top: *Nature 018* **Center:** *Nature 019*
Lower: *Nature 018* **Sides:** *Nature 027*

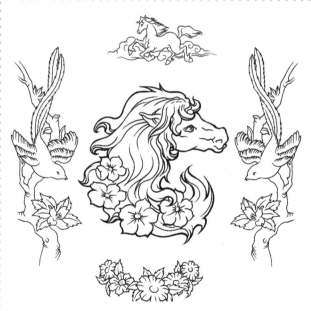

Top: *Nature 027* **Center:** *Nature 035*
Lower: *Nature 020* **Sides:** *Nature 007*

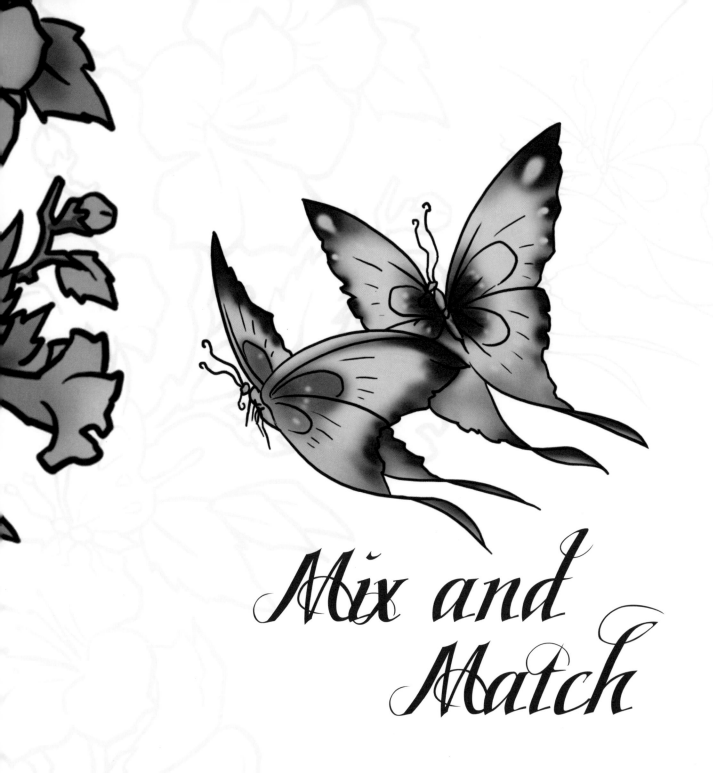

Mix and
Match

Mix and Match

The tattoos have been designed so that all components, regardless of theme, can be interchanged with one another. Using color schemes to unite different elements can make your tattoo more effective. With over a million possible permutations, you can create an original design that is truly unique.

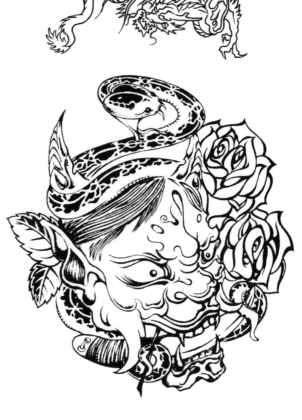

Top: *Traditional 002*
Center: *Horror 020*
Sides: *Tribal 012*

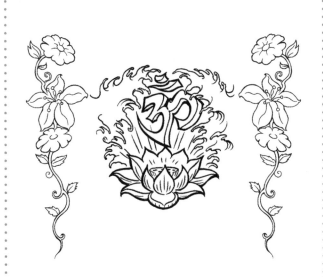

Center: *Asian 017*
Sides: *Nature 022*

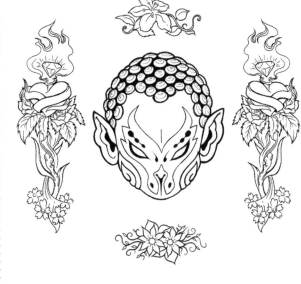

Top: *Nature 022* **Center:** *Asian 015*
Lower: *Mythical 003* **Sides:** *Traditional 031*

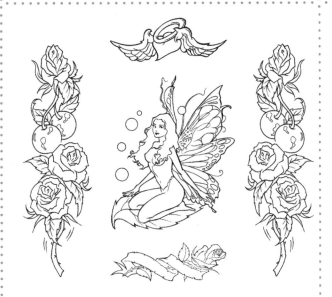

Top: *Mythical 009* **Center:** *Mythical 012*
Lower: *Traditional 018* **Sides:** *Nature 020*

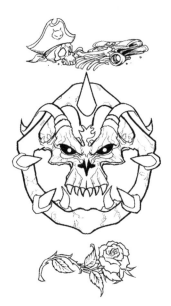

Top: *Nautical 005* **Center:** *Horror 016*
Lower: *Nature 019*

Mix and Match

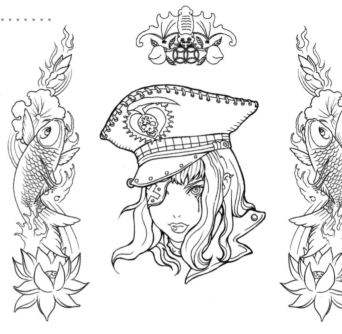

Top: *Asian 007*
Center: *Nautical 008*
Sides: *Nature 015*

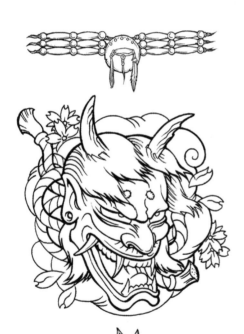

Top: *Nautical 005*
Center: *Horror 019*
Lower: *Traditional 034*

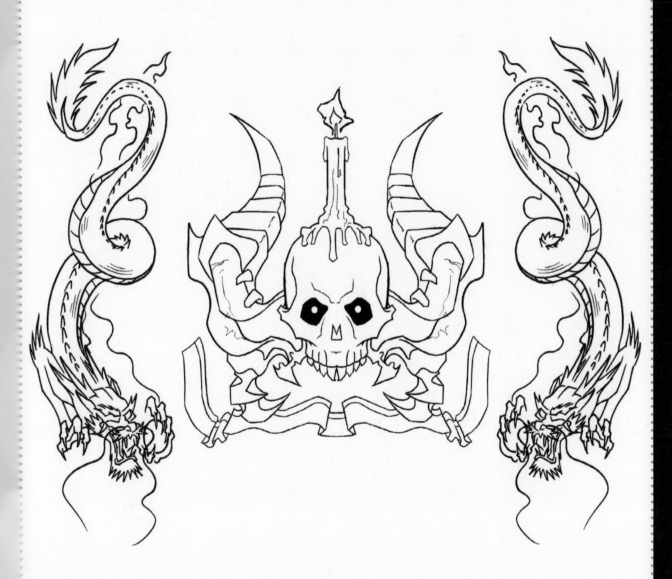

Center: *Horror 017*
Sides: *Mythical 006*

Mix and Match

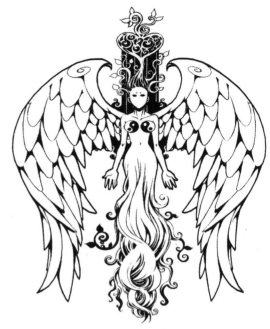

Center: *Traditional 037*

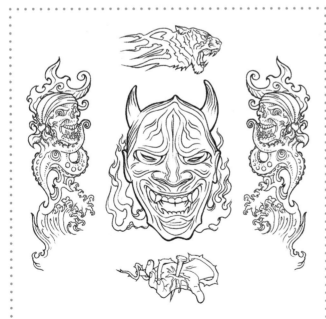

Top: *Tribal 005* **Center:** *Horror 021*
Lower: *Traditional 033* **Sides:** *Nautical 006*

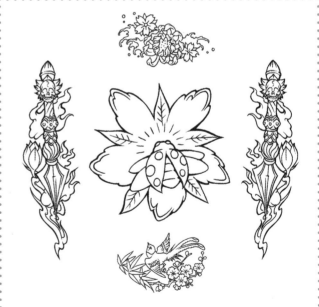

Top: *Mythical 002* **Center:** *Nature 025*
Lower: *Asian 004* **Sides:** *Traditional 028*

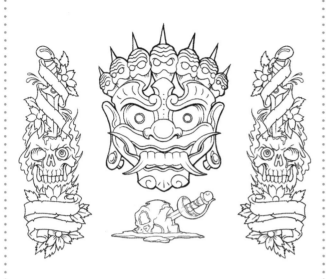

Center: *Tribal 018*
Lower: *Nautical 006* **Sides:** *Horror 005*

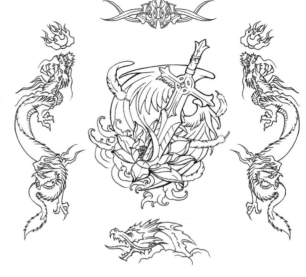

Top: *Horror 011* **Center:** *Traditional 039*
Lower: *Mythical 001* **Sides:** *Asian 005*

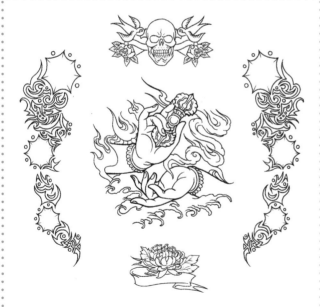

Top: *Traditional 026* **Center:** *Asian 020*
Lower: *Nature 024* **Sides:** *Mythical 007*

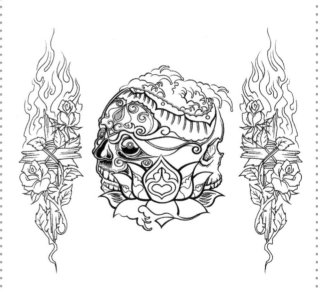

Center: *Tribal 016*
Sides: *Traditional 035*

Mix and Match

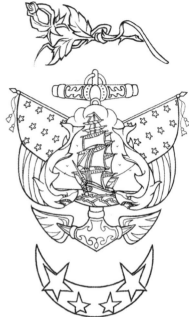

Top: *Nature 019*
Center: *Nautical 007*
Lower: *Mythical 008*

Top: *Asian 003*
Center: *Mythical 009*
Lower: *Tribal 012*
Sides: *Nature 012*

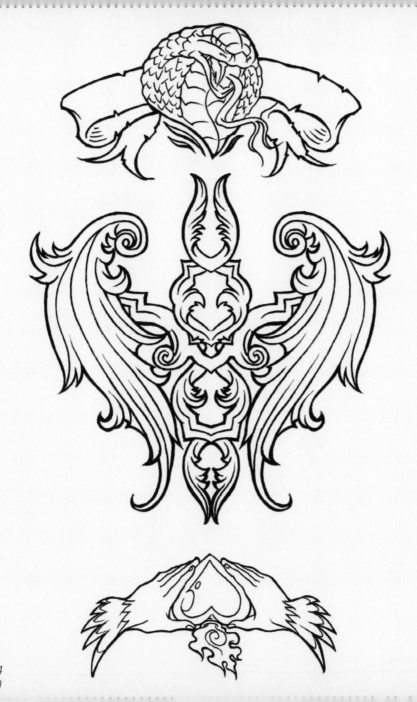

Top: *Nature 003*
Center: *Traditional 044*
Lower: *Traditional 029*

Mix and Match

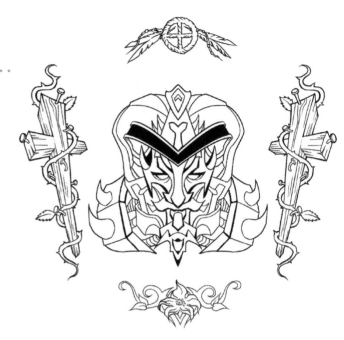

Top: *Tribal 006*
Center: *Tribal 014*
Lower: *Traditional 013*
Sides: *Traditional 033*

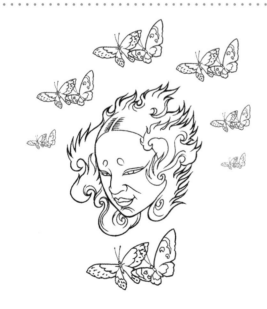

Top: *Nature 024*
Center: *Asian 018*

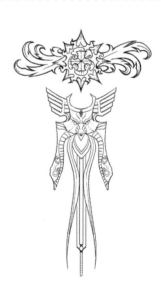

Top: *Traditional 034*
Sides: *Horror 012*

Top: *Nature 013* **Center:** *Traditional 050*
Lower: *Tribal 007* **Sides:** *Mythical 001*

Top: *Horror 013* **Center:** *Mythical 018*
Lower: *Mythical 006* **Sides:** *Traditional 001*

Center: *Mythical 011*
Lower: *Horror 013* **Sides:** *Nature 021*

Top: *Mythical 003* **Center:** *Traditional 040*
Lower: *Nature 024* **Sides:** *Nature 011*

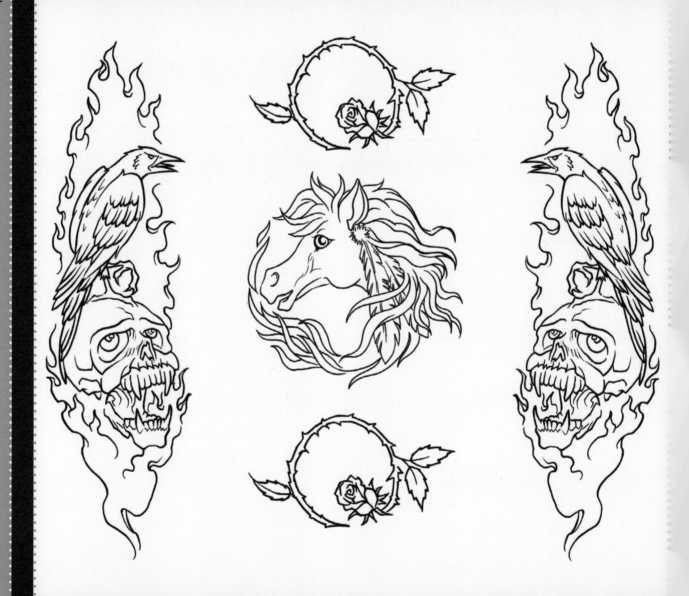

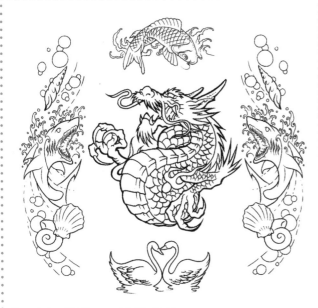

Top: *Asian 001* **Center:** *Mythical 010*
Lower: *Nature 008* **Sides:** *Nautical 004*

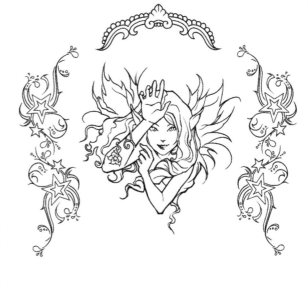

Top: *Asian 009* **Center:** *Mythical 013*
Sides: *Mythical 003*

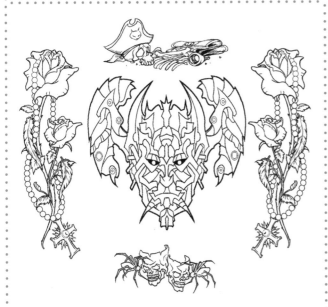

Top: *Nautical 005* **Center:** *Tribal 015*
Lower: *Horror 002* **Sides:** *Traditional 025*

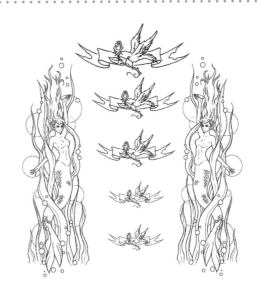

Top: *Traditional 035*
Sides: *Nautical 001*

Mix and Match

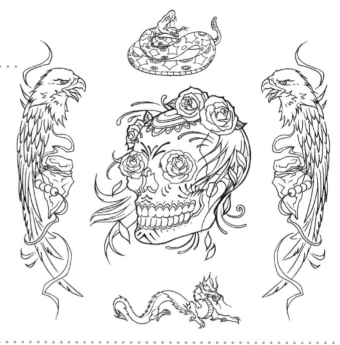

Top: *Nature 011*
Center: *Horror 024*
Lower: *Mythical 005*
Sides: *Tribal 006*

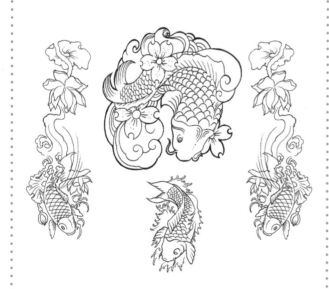

Center: *Nature 021*
Lower: *Nature 015* **Sides:** *Asian 001*

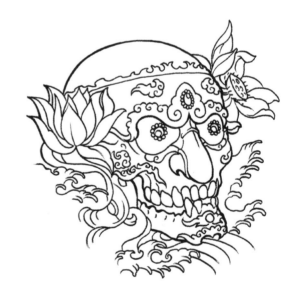

Center: *Traditional 043*

Top: *Traditional 024* **Center:** *Mythical 014*
Lower: *Nature 020*

Center: *Horror 018*
Lower: *Nautical 004* **Sides:** *Asian 010*

Center: *Asian 019*
Sides: *Traditional 013*

Top: *Nature 023* **Center:** *Mythical 017*
Lower: *Nautical 001* **Sides:** *Asian 003*

Chinese Zodiac Characters

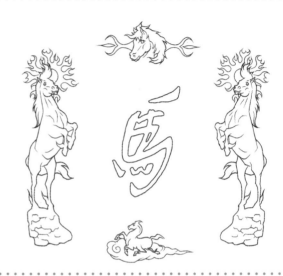

Top: *Nature 029*
Center: *Asian 028 (Horse)*
Lower: *Nature 028*
Sides: *Nature 028*

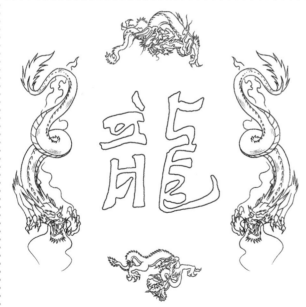

Top: *Traditional 002* **Center:** *Asian 026 (Dragon)*
Lower: *Traditional 002* **Sides:** *Mythical 006*

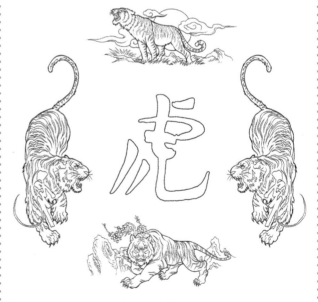

Top: *Nature 002* **Center:** *Asian 035 (Tiger)*
Lower: *Nature 002* **Sides:** *Nature 002*

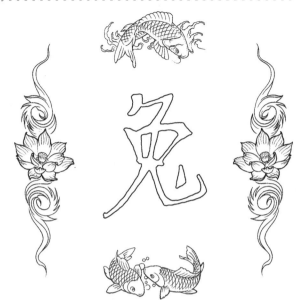

Top: *Asian 001* **Center:** *Asian 027 (Hare)*
Lower: *Asian 001* **Sides:** *Asian 008*

Center: *Asian 024*
Meaning: *Boar*

Center: *Asian 025*
Meaning: *Dog*

Center: *Asian 026*
Meaning: *Dragon*

Center: *Asian 027*
Meaning: *Hare*

Center: *Asian 028*
Meaning: *Horse*

Center: *Asian 029*
Meaning: *Monkey*

Center: *Asian 030*
Meaning: *Ox*

Center: *Asian 031*
Meaning: *Ram*

Center: *Asian 032*
Meaning: *Rat*

Center: *Asian 033*
Meaning: *Rooster*

Center: *Asian 034*
Meaning: *Snake*

Center: *Asian 035*
Meaning: *Tiger*

127

One Million Tattoos *License Agreement*

The One Million Tattoos *image gallery of digitized images ("The Images") on this CD-ROM disc ("The Disc") is licensed for use under the following Terms and Conditions, which define what You may do with the product. Please read them carefully. Use of The Images on The Disc implies that You have read and accepted these terms and conditions in full. If You do not agree to the terms and conditions of this agreement, do not use or copy The Images, and return the complete package to The Ilex Press Ltd. with proof of purchase within 15 days for a full refund.*

Terms and Conditions of Use
You agree to use The Images under the following Terms and Conditions:

Agreement
1. These Terms and Conditions constitute a legal Agreement between the purchaser ("You" or "Your") and The Ilex Press Ltd. ("Ilex").

2. License
You are granted a non-exclusive, non-transferable license to use, modify, reproduce, publish, and display The Images provided that You comply with the Terms and Conditions of this Agreement.

3. You may, subject to the Terms and Conditions of this Agreement:
a) Use, modify, and enhance The Images (provided that You do not violate the rights of any third party) as a design element in commercial or internal publishing, for advertising or promotional materials, corporate identity, newsletters, video, film, and television broadcasts except as noted in paragraph 4 below.

b) Use, modify, and enhance the images as a design element on a Web site, computer game, video game, or multimedia product (but not in connection with any Web site template, database, or software product for distribution by others) except as noted in paragraph 4 below.

c) Use one copy of The Disc on a single workstation only.

d) Copy the images to Your hard drive.

e) Make a temporary copy of The Images, if You intend to output the images using a device owned or operated by a third party, such as a service bureau image setter. Such copies must be destroyed at the end of the production cycle.

4. You may not:
a) Distribute, copy, transfer, assign, rent, lease, resell, give away, or barter the images, electronically or in hard copy, except as expressly permitted under paragraph 3 above.

b) Distribute or incorporate the images into another photo or image library or any similar product, or otherwise make available The Images for use or distribution separately or detached from a product or Web page, either by copying or electronically downloading in any form.

c) Use the The Images to represent any living person.

d) Modify and use The Images in connection with pornographic, libelous, obscene, immoral, defamatory, or otherwise illegal material.

e) Use The Images as part of any trademark whether registered or not.

f) Transfer possession of The Images to another person across a network, on a CD, or by any other method now known or hereafter invented.

5. Termination
This license is in force until terminated. If You do not comply with the terms and conditions above, the license automatically terminates. At termination, the product must be destroyed or returned to Ilex.

6. Warranties
a) Ilex warrants that the media on which The Images are supplied will be free from defects in material and workmanship under normal use for 90 days. Any media found to be defective will be replaced free of charge by returning the media to our offices with a copy of Your receipt. If Ilex cannot replace the media, it will refund the full purchase price.

b) The Images are provided "as is," "as available," and "with all faults," without warranty of any kind, either expressed or implied, including but not limited to the implied warranties or merchantability and fitness for a particular purpose. The entire risk as to quality, accuracy, and performance of The Images is with You. In no event will Ilex, its employees, directors, officers, or its agents or dealers or anyone else associated with Ilex be liable to You for any damages, including any lost profit, lost savings, or any other consequential damages arising from the use of or inability to use The Images even if Ilex, its employees, directors, officers, or its agent or authorized dealer or anyone else associated with Ilex has been advised of the possibility of such damages or for any claim by any other party. Our maximum liability to You shall not exceed the amount paid for the product.

c) You warrant You do not reside in any country to which export of USA products is prohibited or restricted or that Your use of The Images will not violate any applicable law or regulation of any country, state, or other governmental entity.

d) You warrant that You will not use The Images in any way that is not permitted by this Agreement.

7. General
a) The Disc, The Images, and its accompanying documentation is copyrighted. You may digitally manipulate, add other graphic elements to, or otherwise modify The Images in full realization that they remain copyrighted in such modification.

b) The Images are protected by the United States Copyright laws, international treaty provisions, and other applicable laws. No title to or intellectual property rights to The Images or The Disc are transferred to You.

c) You acknowledge that You have read this agreement, understand it, and agree to be bound by its terms and conditions. You agree that it supersedes any proposal or prior agreement, oral or written, and that it may not be changed except by a signed written agreement.